13

Ipswich

A Celebration of Light, Land, and Sea

Photographs by Andrew Borsari

COMMONWEALTH EDITIONS
Beverly, Massachusetts

The author gratefully acknowledges Harry Leno, for his insight on
Ipswich, and Kathy Berggren, for her generous help early on.
With many thanks to Shawna Mullen, for her editorial assistance;
to Jill Feron, for her design; and to studio colleagues Skip Kaminsky
and Russ Scahill, for the hard work and the laughs.

ISBN 1-889833-29-0

Cover and interior design by Jill Feron/Feron Design.
Printed in Singapore.

Published by Commonwealth Editions,
an imprint of Memoirs Unlimited, Inc.,
21 Lothrop Street, Beverly, Massachusetts 01915.
Visit our Web site: www.commonwealtheditions.com.

Andrew Borsari's photographs are available at
the Borsari Gallery, Tuna Wharf, Rockport, Massachusetts 01966.
E-mail: borsarigallery@attbi.com

This book is dedicated to the memory of Andrea.

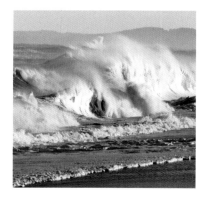

*T*grew up in a town in western Massachusetts. When I was seven years old, my family moved from a residential area to a more rural setting on Riverdale Road, along the Connecticut River. On the new property were a large house built in 1888 and a small, tidy barn with an apple orchard nearby.

Behind the orchard was a wide brook that flowed into a pond. At the end of the pond was a small overflow gate allowing the water to continue underground to the Connecticut River. Behind the brook and pond were eighteen acres of open field leading to rolling hills and forest, where the brook had its source. On both sides of our property were working farms of greater acreage.

In the 1950s, U.S. Route 91 was built across the Connecticut River a few hundred yards away. Soon after, all the farms in the area succumbed to the pressures of commercial expansion and so-called progress. All but one of the twenty-seven houses on my boyhood paper route vanished. The forest and rolling hills that I loved to wander were cut down and leveled flat. The brook and pond were filled in, the water piped underground. Fish and wildlife disappeared, and some of the richest soil on earth was paved over with hardtop. The town gave way to urban sprawl and became a city.

Today on that eighteen-acre site there is a Burger King where our house was, a Ramada Inn behind the old brook. There is not a trace to tell the tale of where I once lived except, perhaps, Route 91 crossing the river. When I go back to see friends and relatives, and drive by Riverdale Road, I am haunted by the words of American novelist Thomas Wolfe, "You can't go home again."

About twenty years ago, my wife and I wanted to relocate to the Boston's

North Shore, near the ocean. After many weekend trips, we discovered Ipswich, and I knew then that I wanted to live somewhere in this town. In the spring of 1982, we secured a small fixer-upper on Great Neck. We realized immediately that, in Ipswich, you're not buying a house, you're buying a location. The house has improved over time.

Massachusetts is the third most densely populated state in the country. Ipswich, one of the oldest towns in America, has grown at a slower pace. From Puritan pride to ethnic struggle and assimilation, Ipswich has kept its character and identity. Today, Ipswich is admired for its open, beautiful land-scapes and the largest collection of First Period houses in America. Ipswich people have made a commitment to conservation.

There is so much in the town's thirty-three square miles that did not make this book. For this I apologize. With painful editing, we focused on a visual balance and integrity. I have made Ipswich my home for the last twenty years and have not taken one day for granted. In a town like Ipswich, you can go home again.

—Andrew Borsari, March 2002

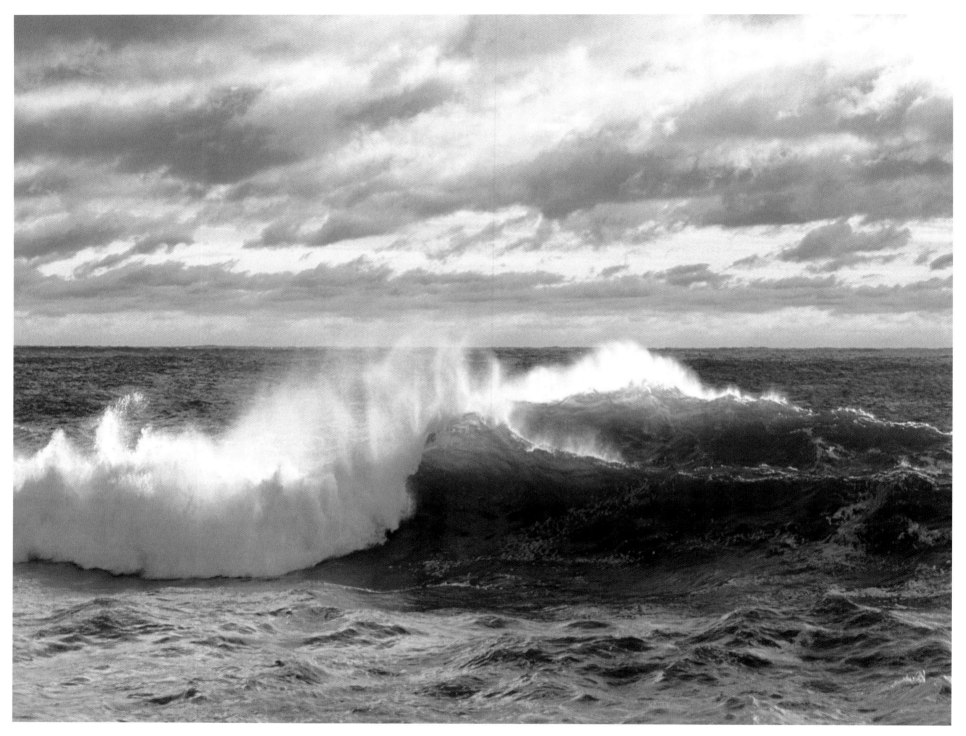

Ocean Wave

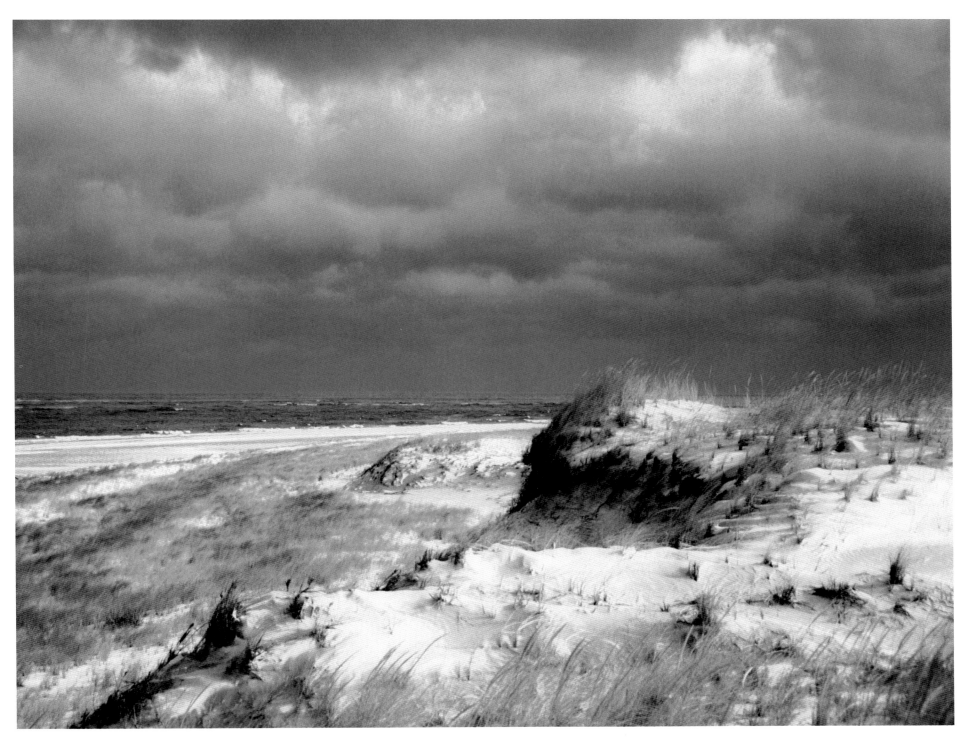

Atlantic Tempest, Crane Beach

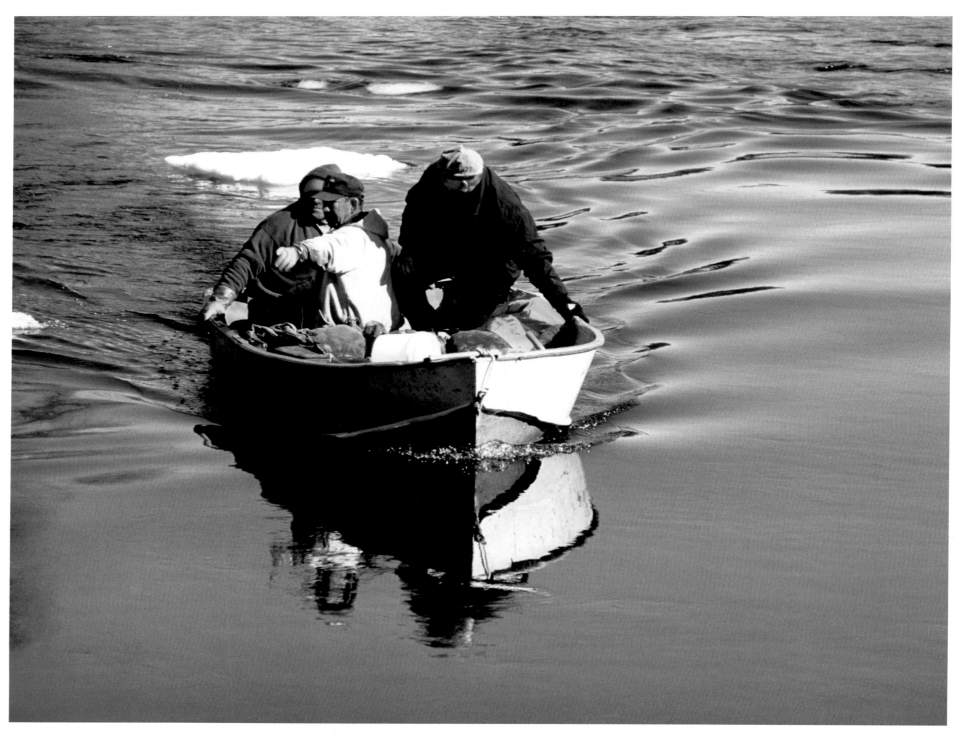

Clammers Returning to Town Wharf

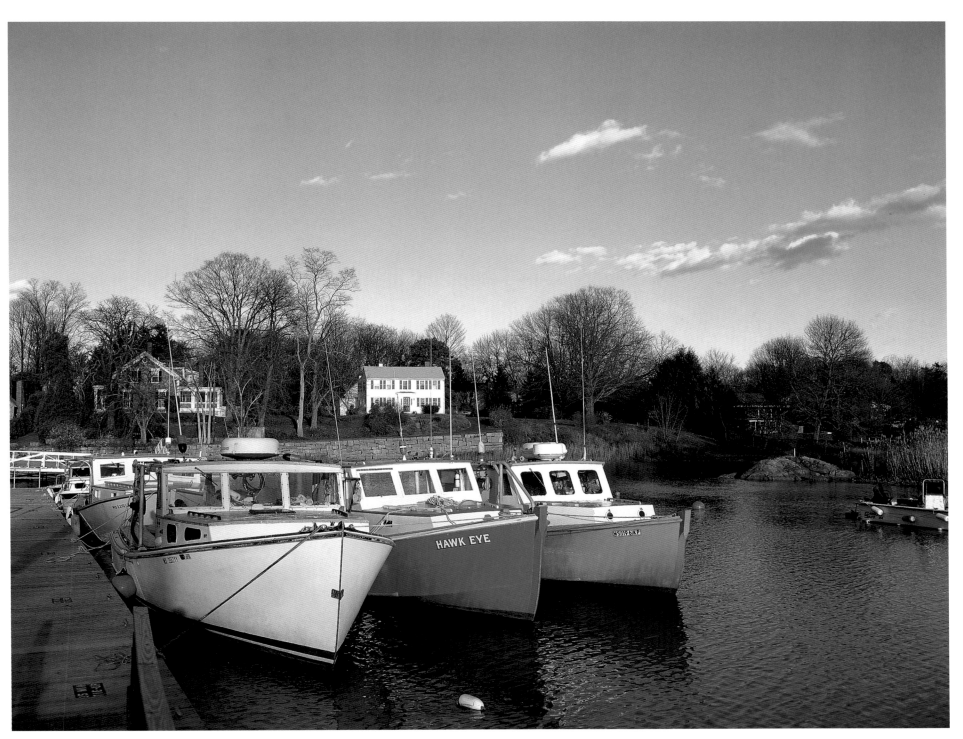

Town Wharf. *It's rare to find no one at town wharf. It's a meeting place, for socializing, making acquaintances, reading the paper. Boats are launched here, too, at high tide.*

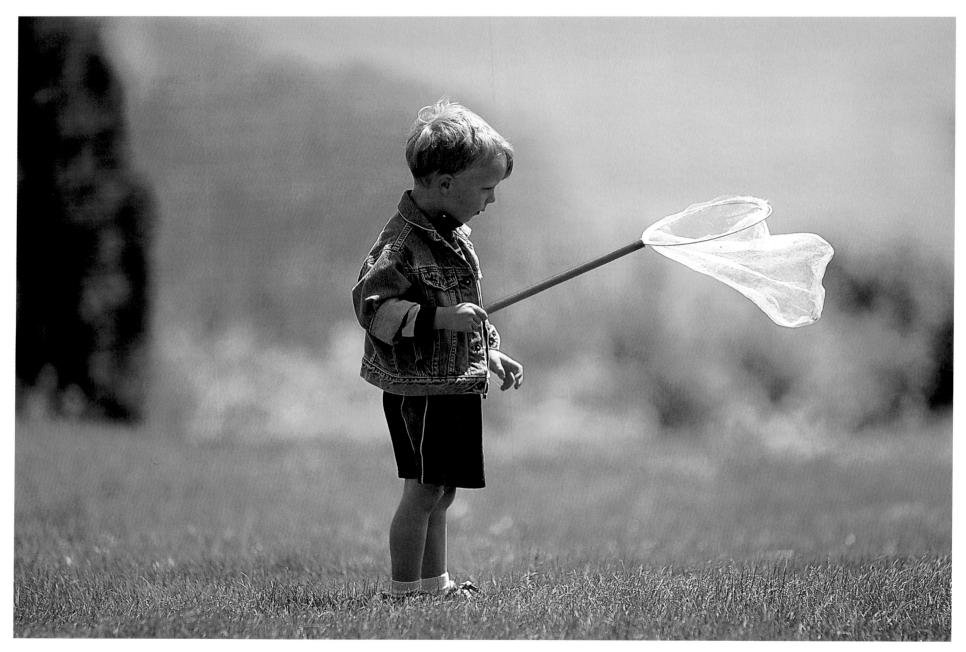

Will. *With wonder about all things in nature.*

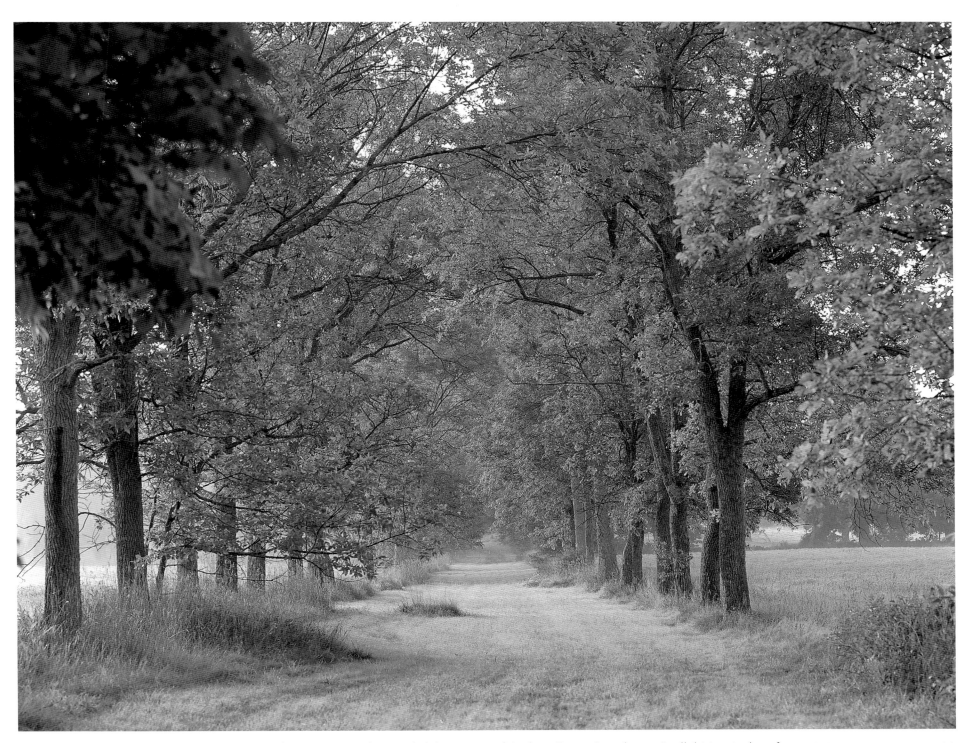

Appleton Farms, Summer. *For eighteen years, I've photographed the perimeter of Appleton Farms. Several times, I called Mrs. Appleton for permission to enter. She kindly agreed, but the sweet light of the moment seemed lost when I arrived ready to shoot. Now that the property is open to all, I have no excuses.* 11

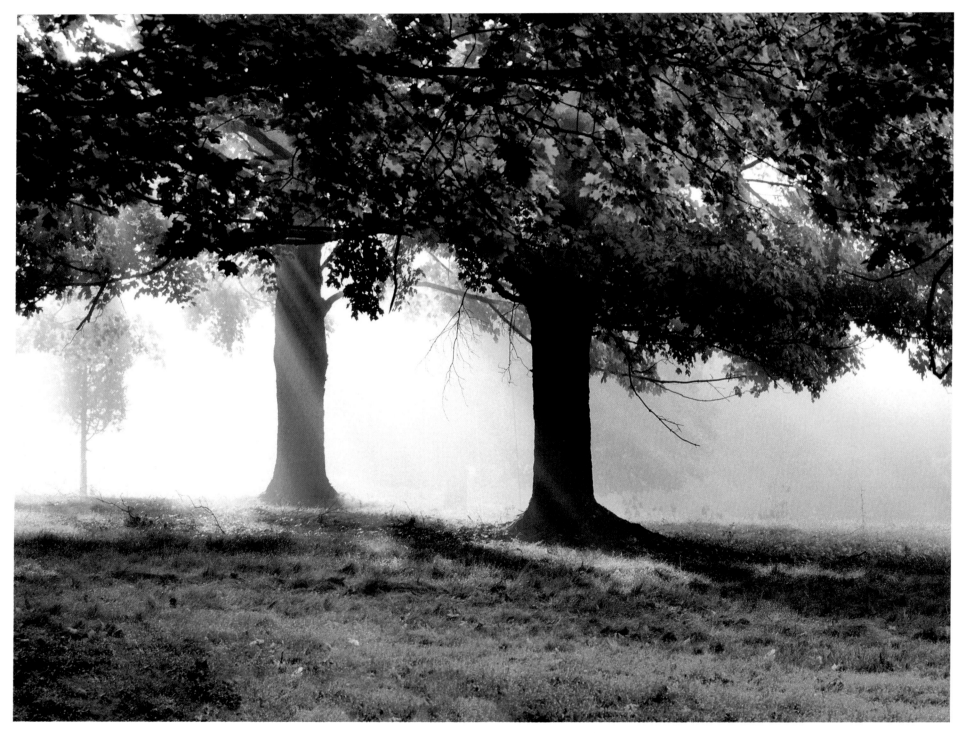

First Light. *What I like most about Appleton Farms is the layout of trees planned over time.*

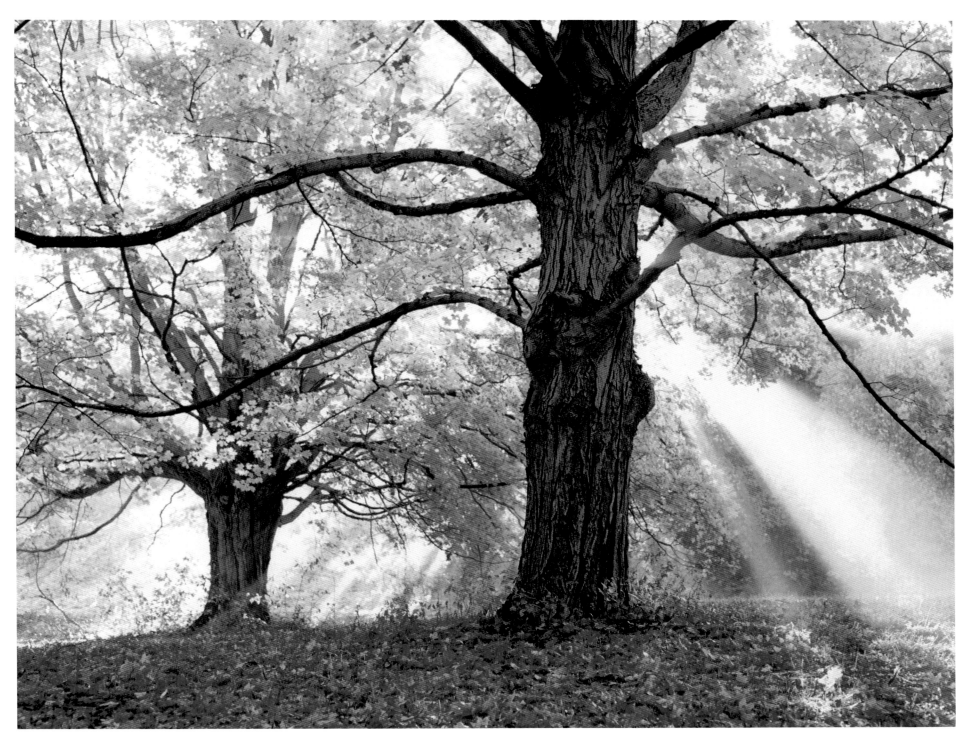

Sunburst, Appleton Farms

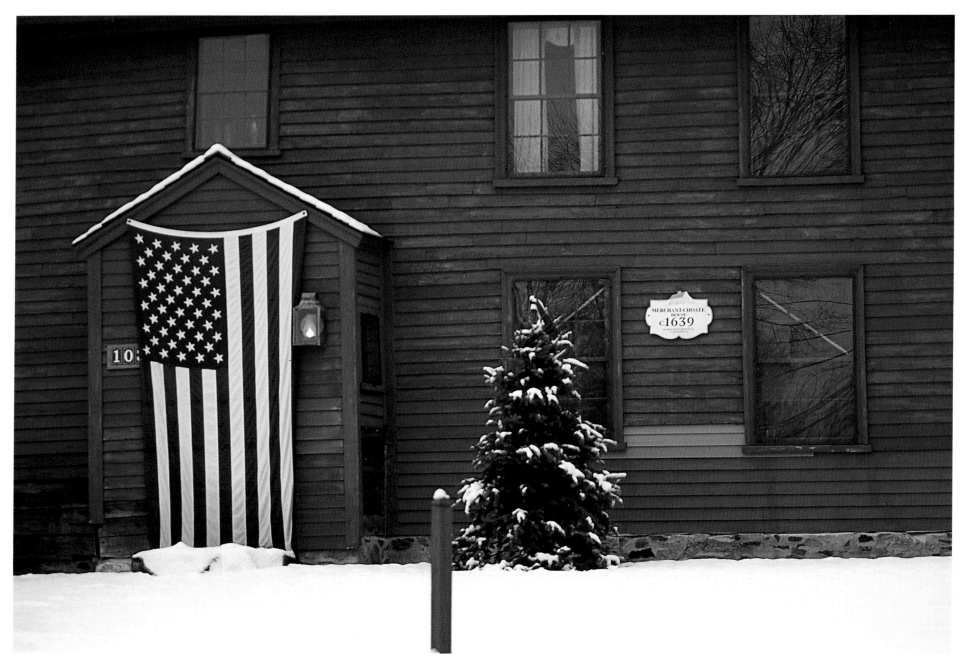

Merchant-Choate House, 1639

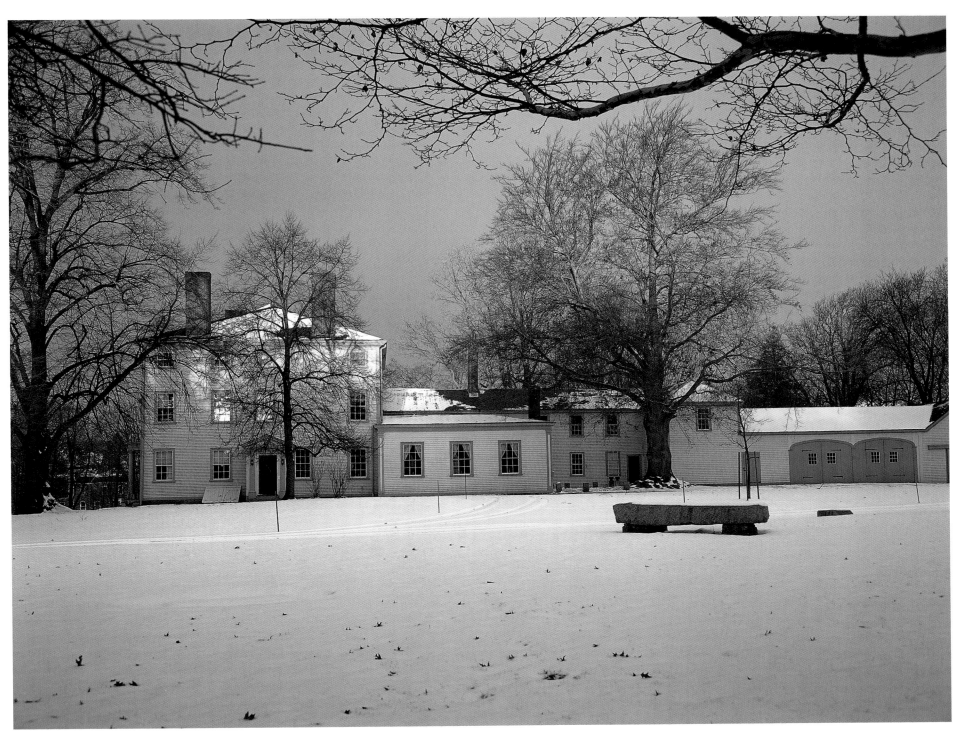

Heard House Museum, 1800, Ipswich Historical Society.

Visit the Heard House, close your eyes for a moment, and take in the fragile scent of antiquity from Ipswich to the China trade.

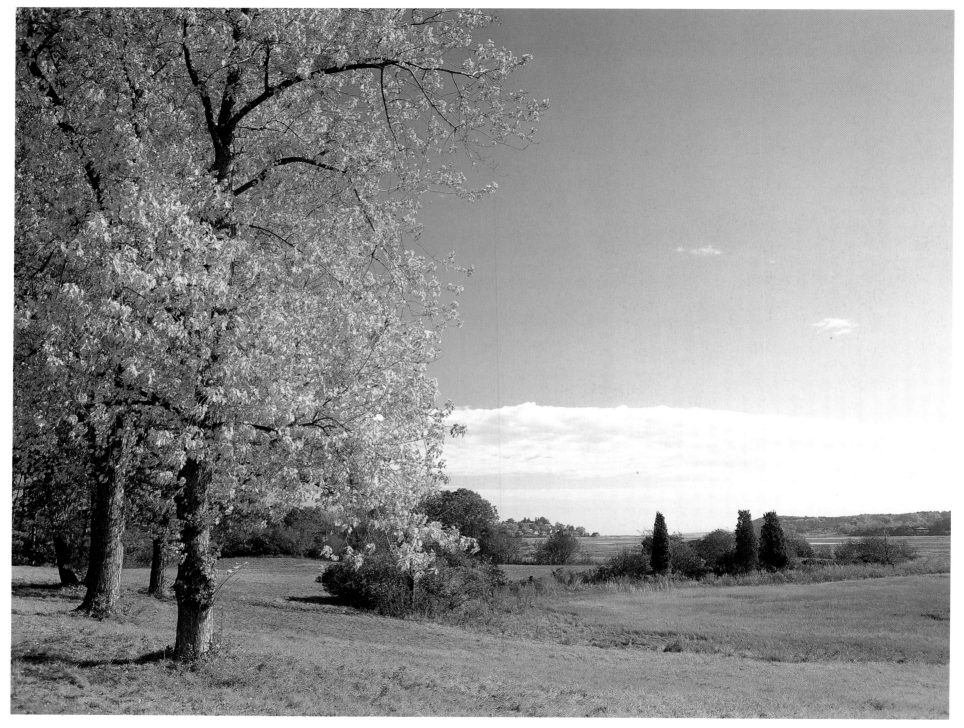

Greenwood Farm to Little Neck

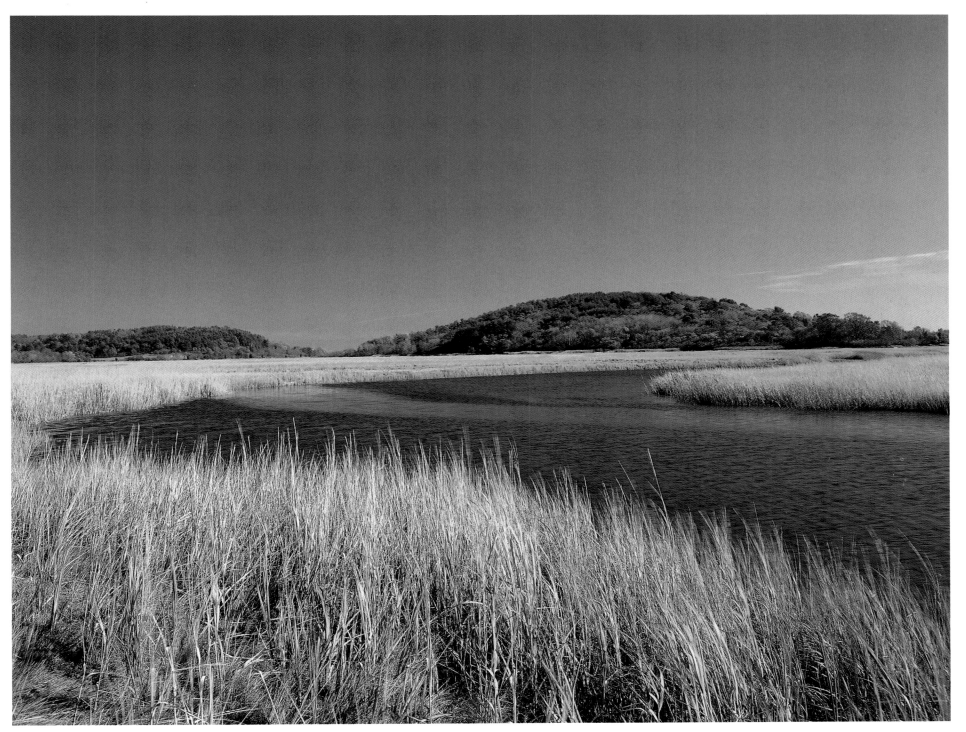

Late Summer, Neck Creek

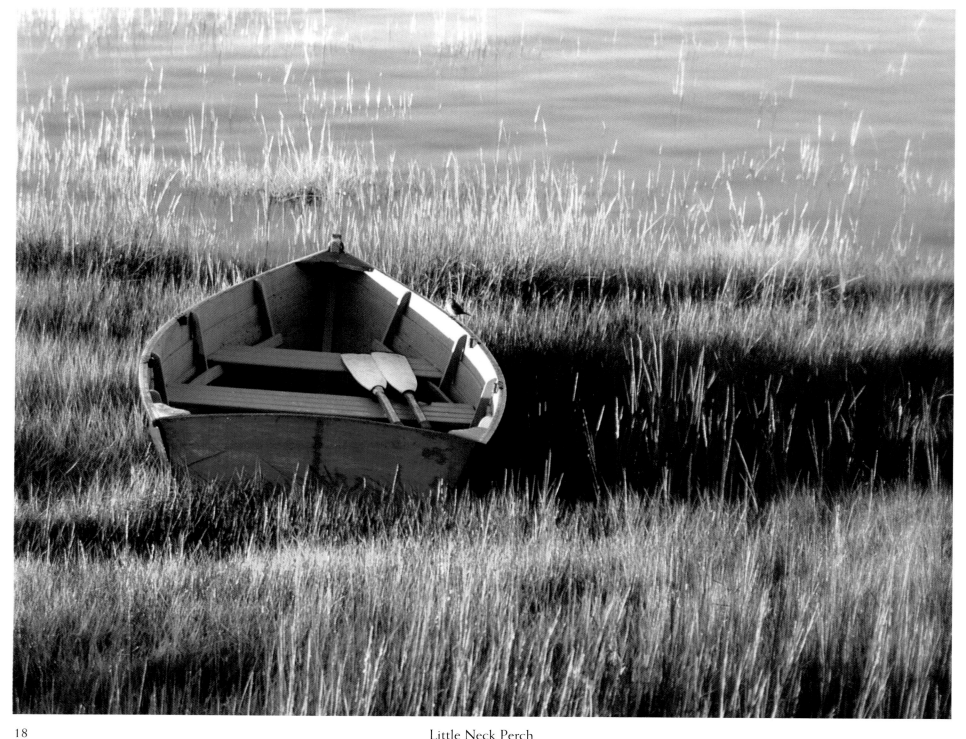

Little Neck Perch

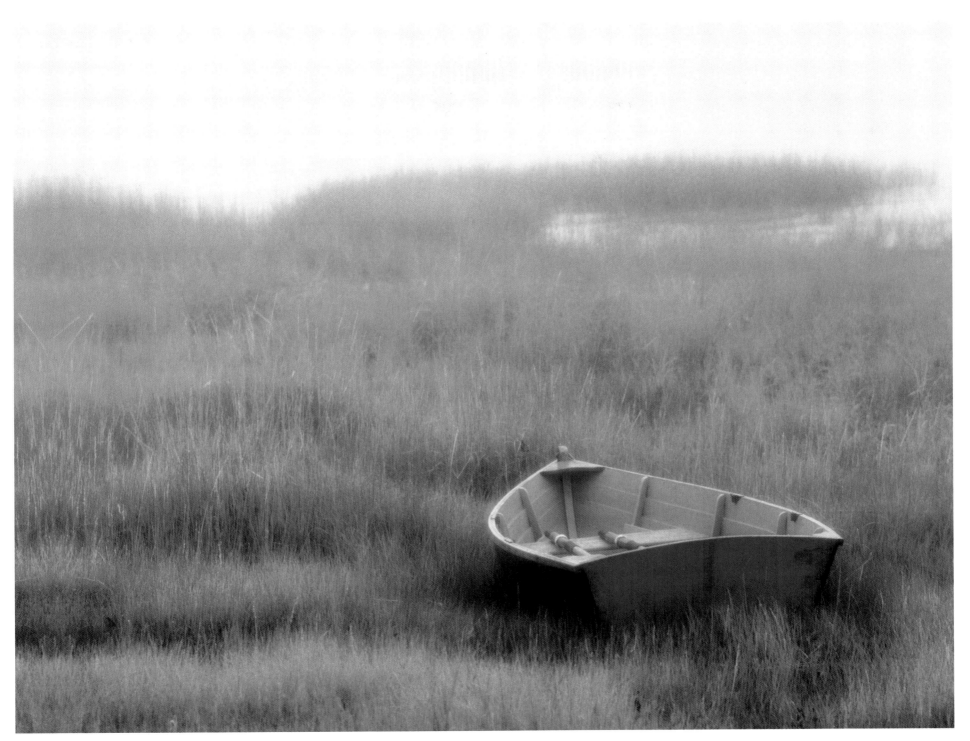

Little Neck Skiff in the Fog. *Same boat, same scene, under the rendering spell of light.*

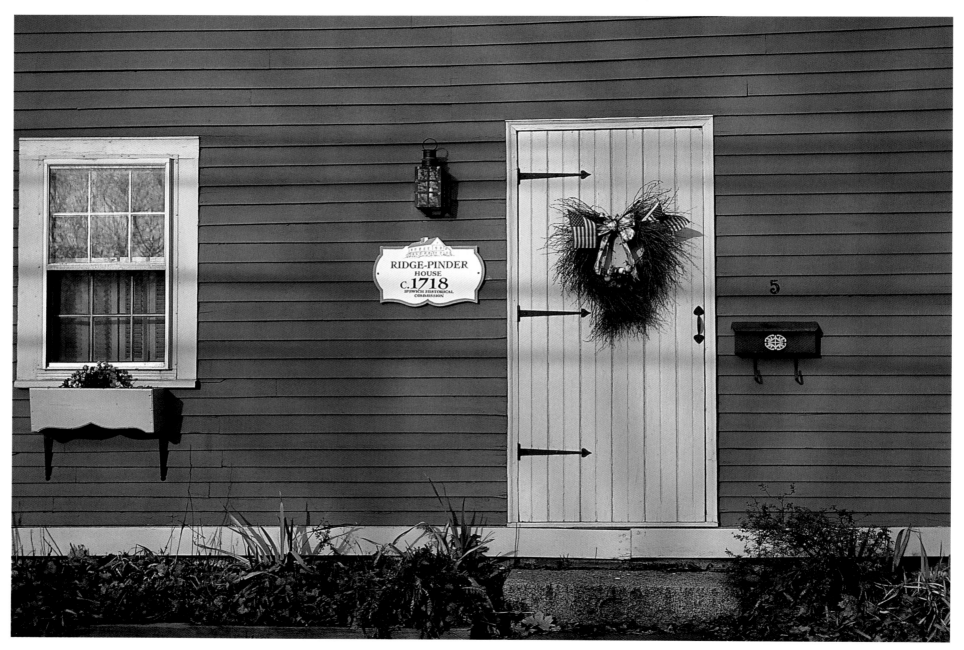

Ridge-Pinder House, circa 1718

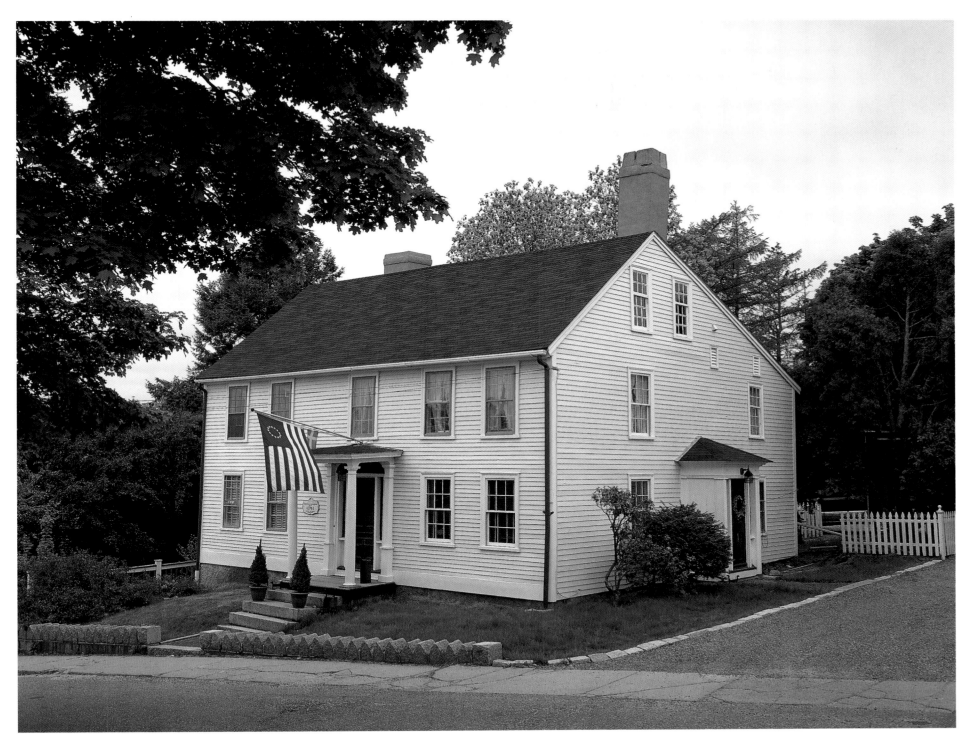

Christian Wainright House, circa 1741

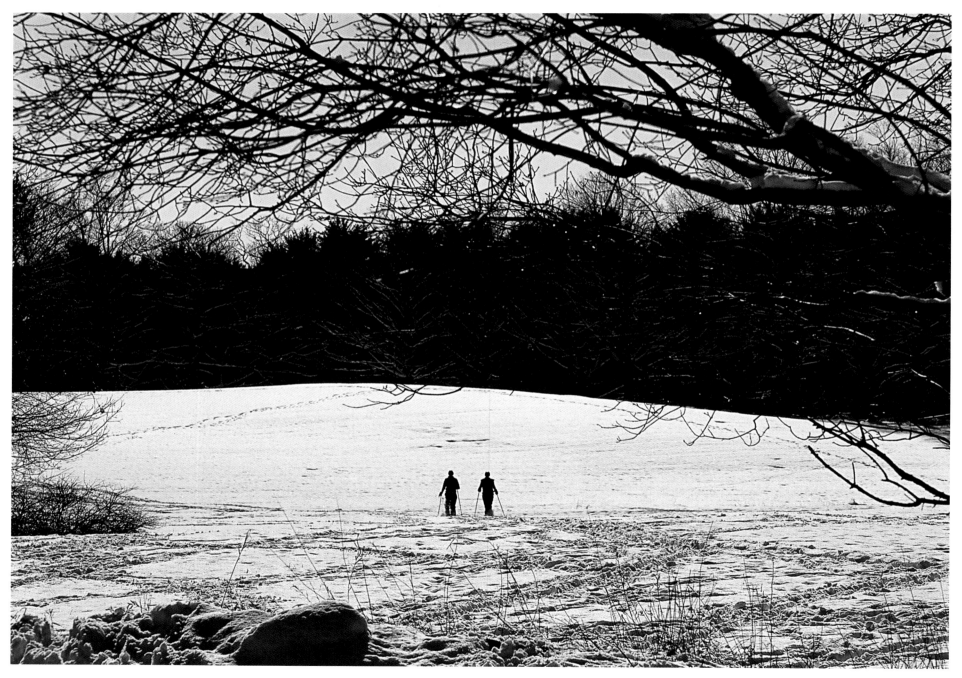

Appleton Farms

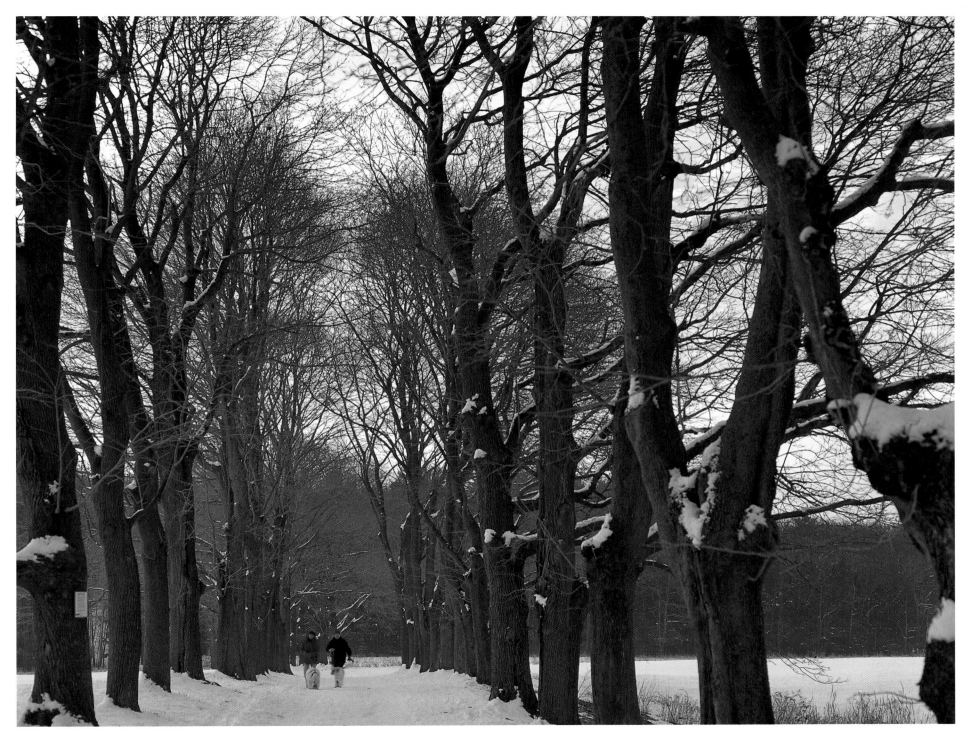

Dog Walk, Appleton Farms.

Every morning, weather permitting, women gather with their dogs to walk down the tree-lined corridor of Appleton Farms. Fresh air, exercise, and a social hour for all.

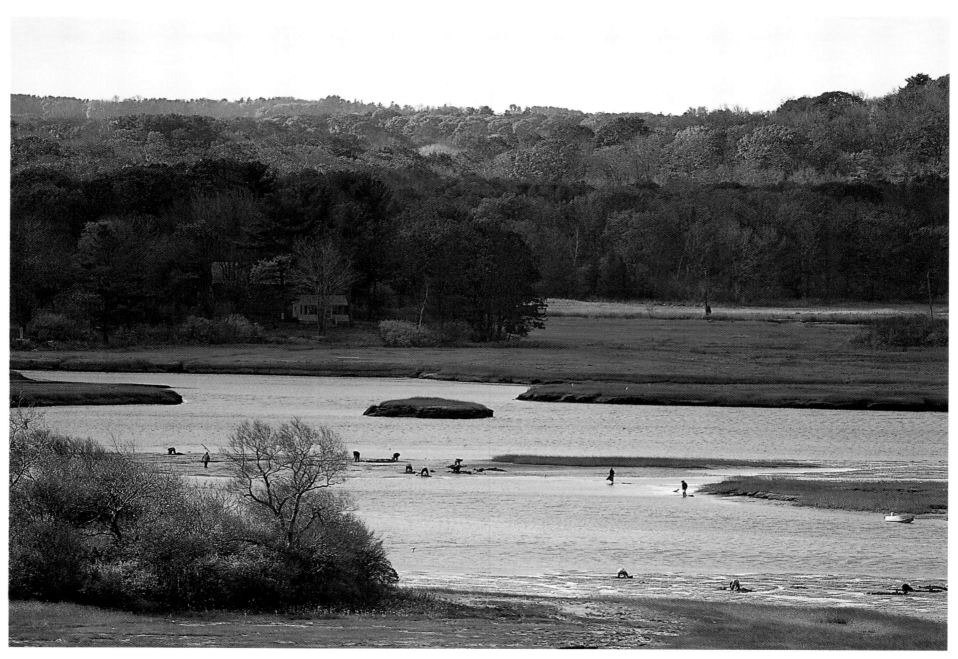

Clammers on the Ipswich. *In their words, it's* digger, *not* clammer, *and they prefer to be out here than at any desk job.*

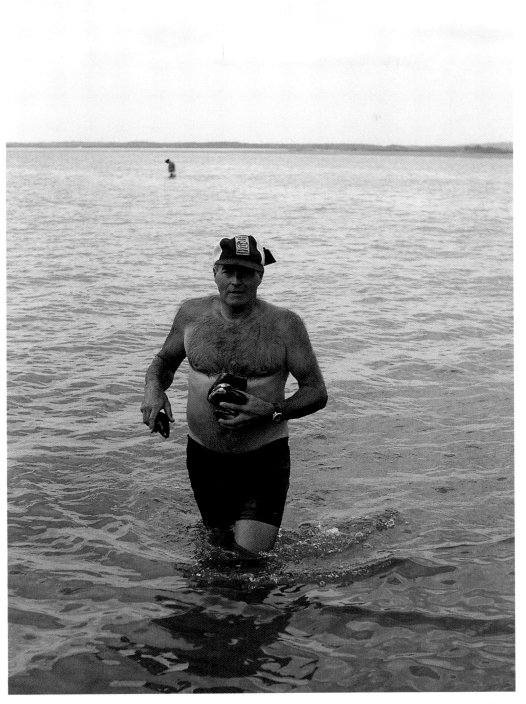

Durrie Robinson on Middle Ground. *In memory of my friend, who showed me the waterways of Ipswich.*

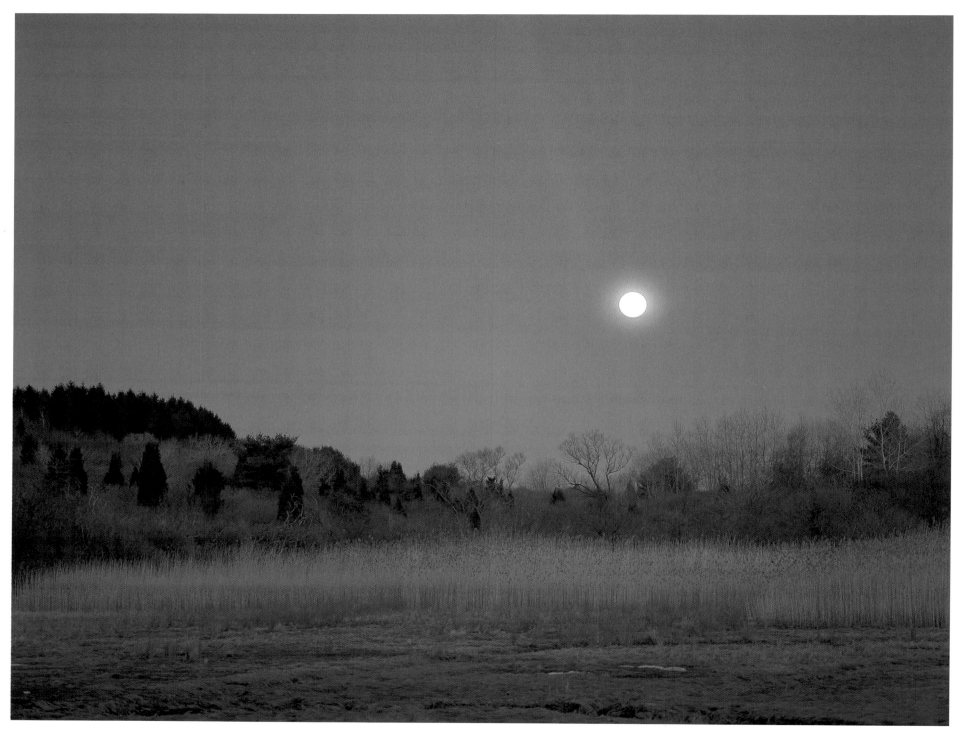

Snow Moon. *A ring around the moon—snow is on the way.*

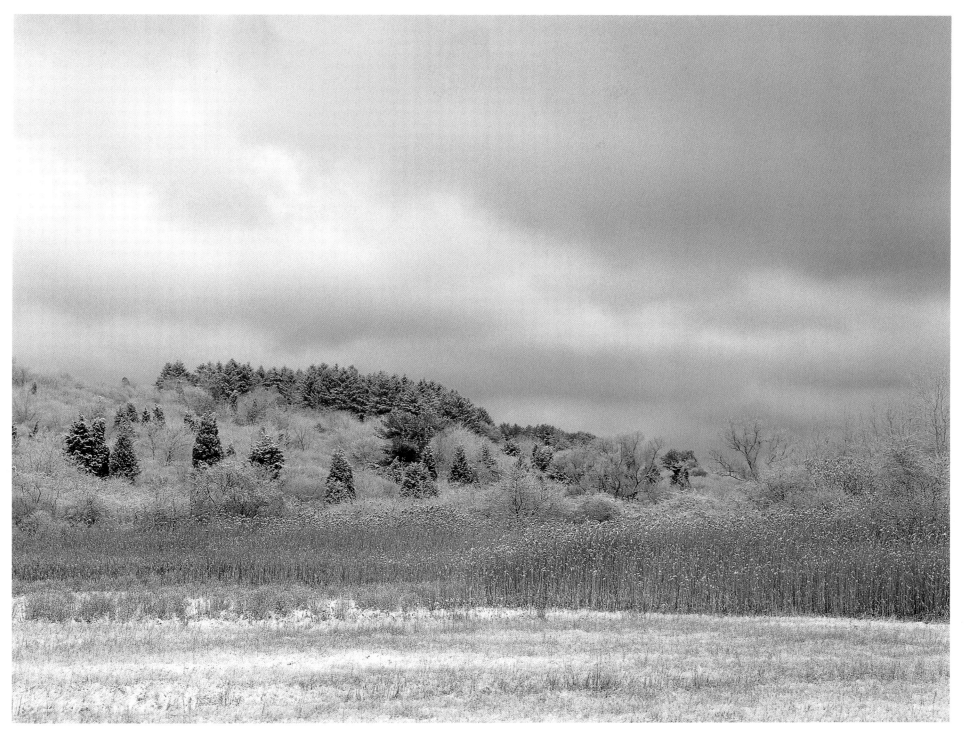

Morning After

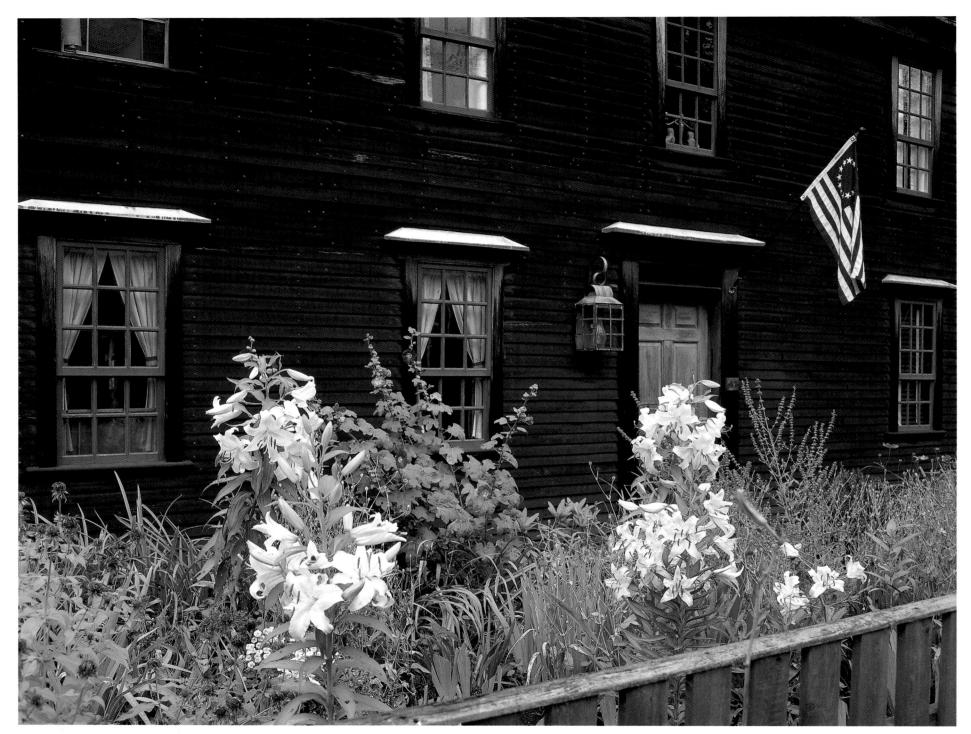

Benjamin Grant House

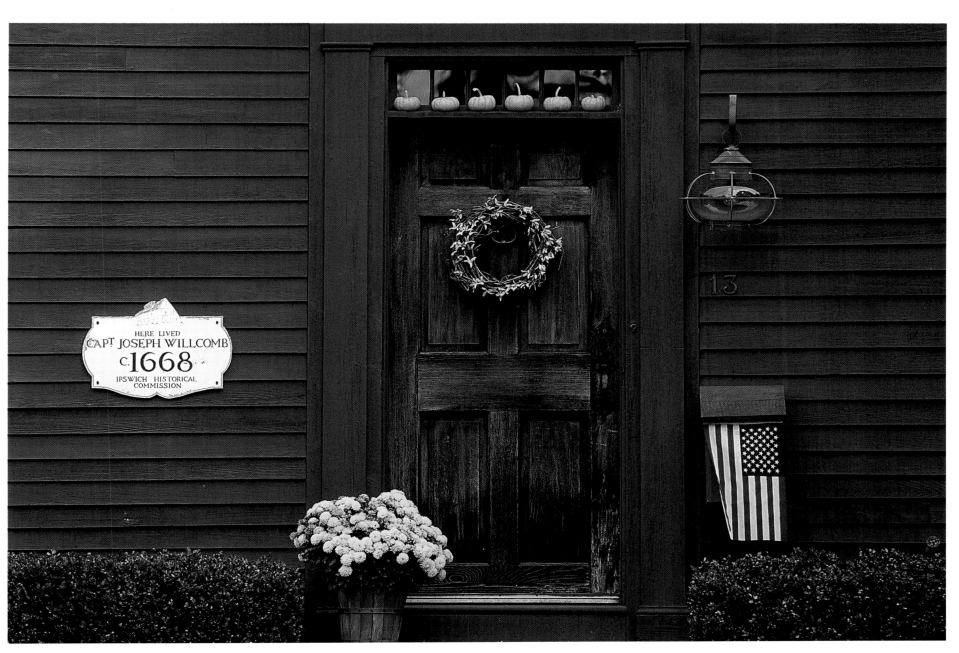

Capt. Joseph Willcomb House, circa 1668

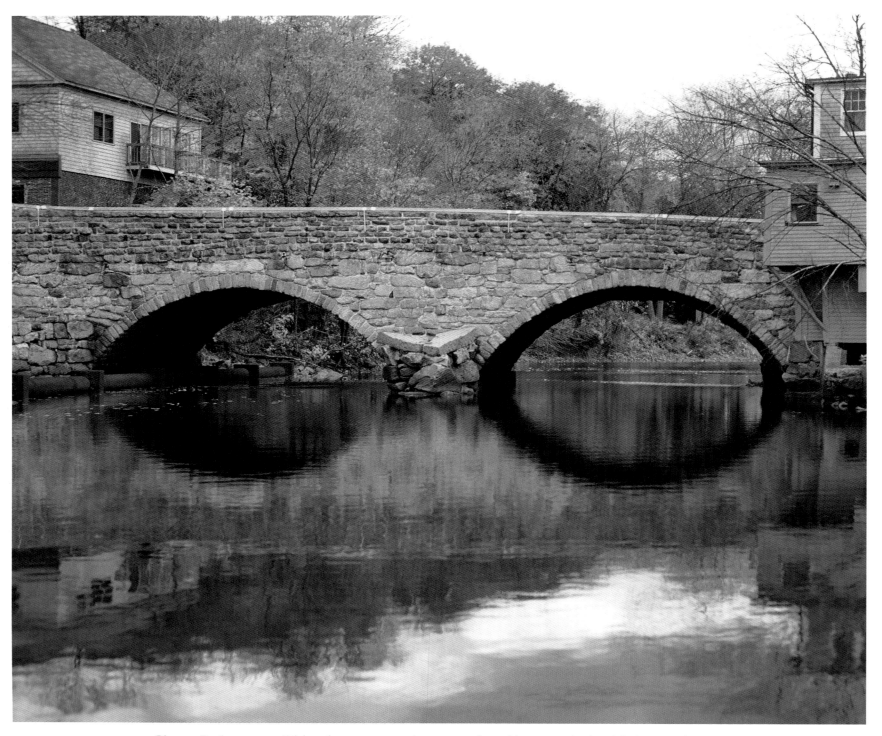

Choate Bridge, 1764. *With nothing to paint, nothing to rust, Ipswich's signature landmark looks as good as ever.*
Built by Col. John Choate for less than £1,000, it is today the oldest stone-arch bridge in continuous use in Massachusetts.

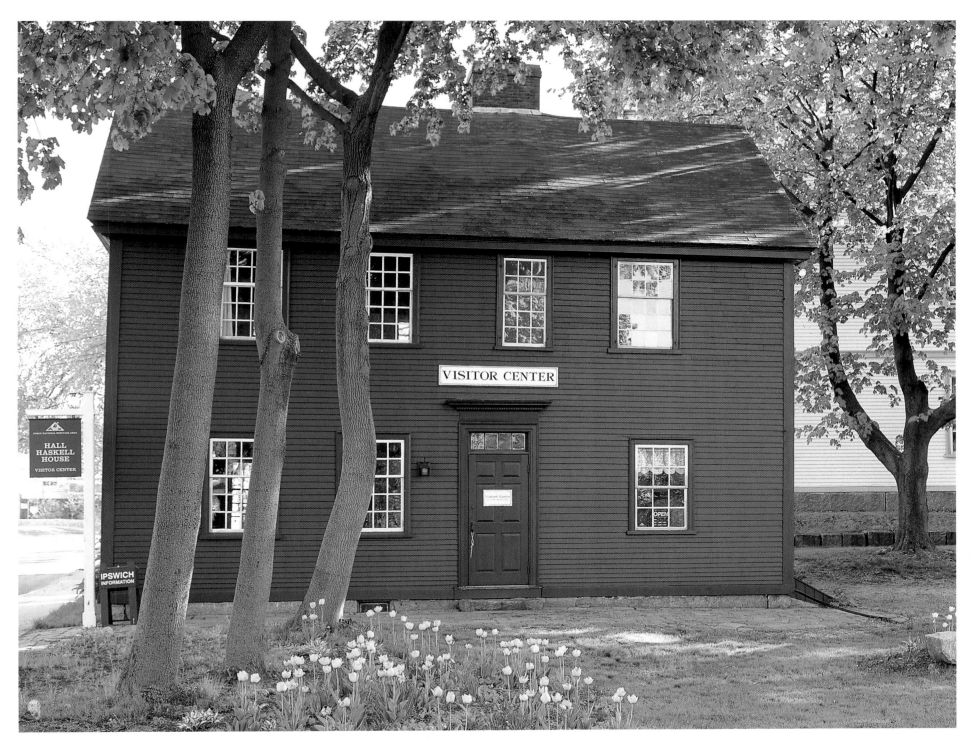

Hall-Haskell House, 1819. *A greeting place for visitors and a showplace for Ipswich artists.*

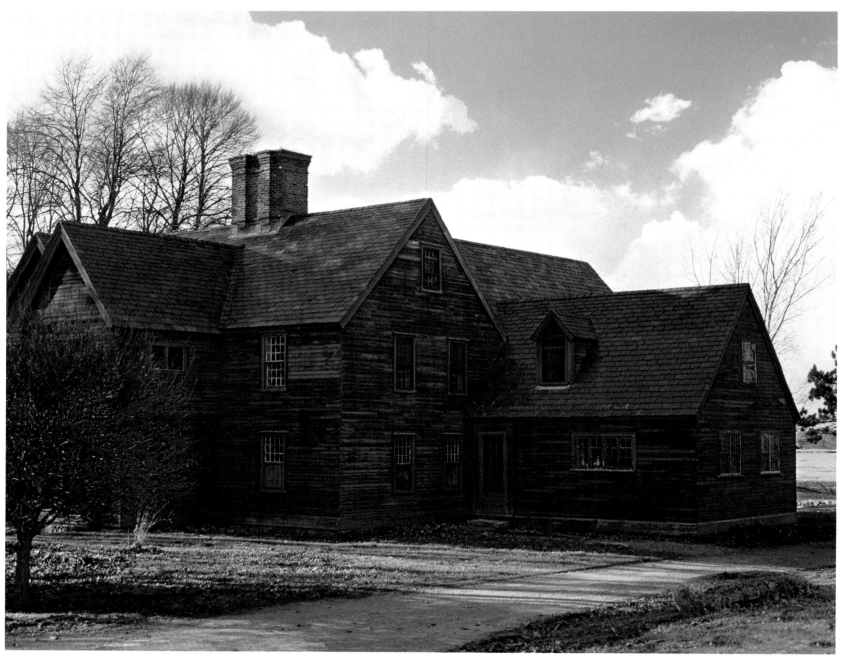

Collins-Lord House, Strawberry Hill, 1675

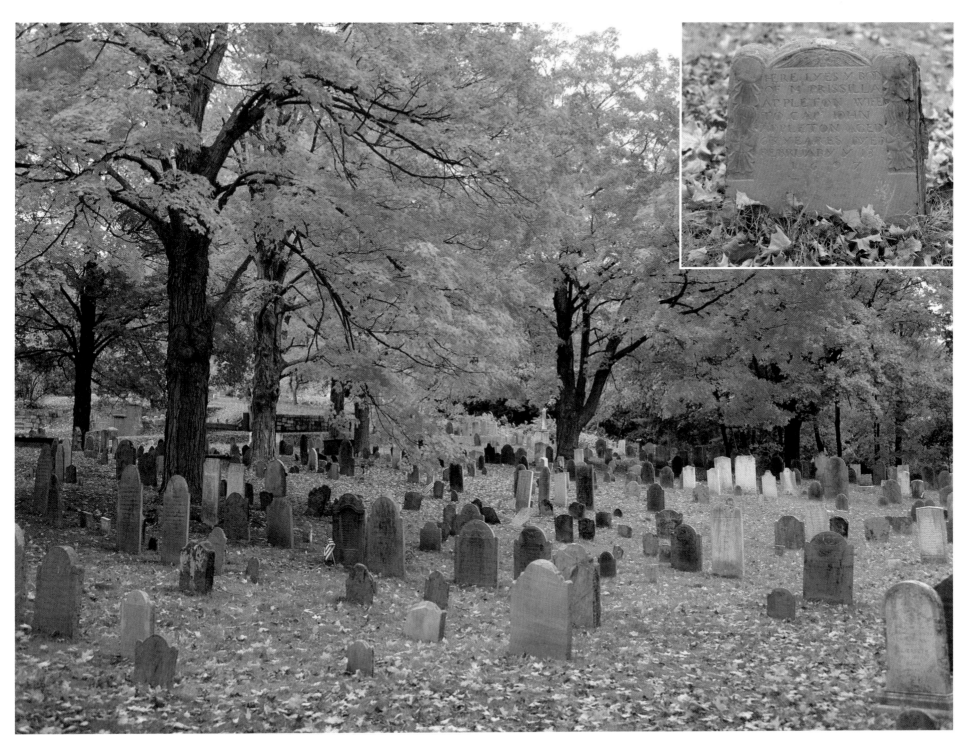

The Old Burying Ground, 1634. Inset: Prissilla Appleton, died 1697.

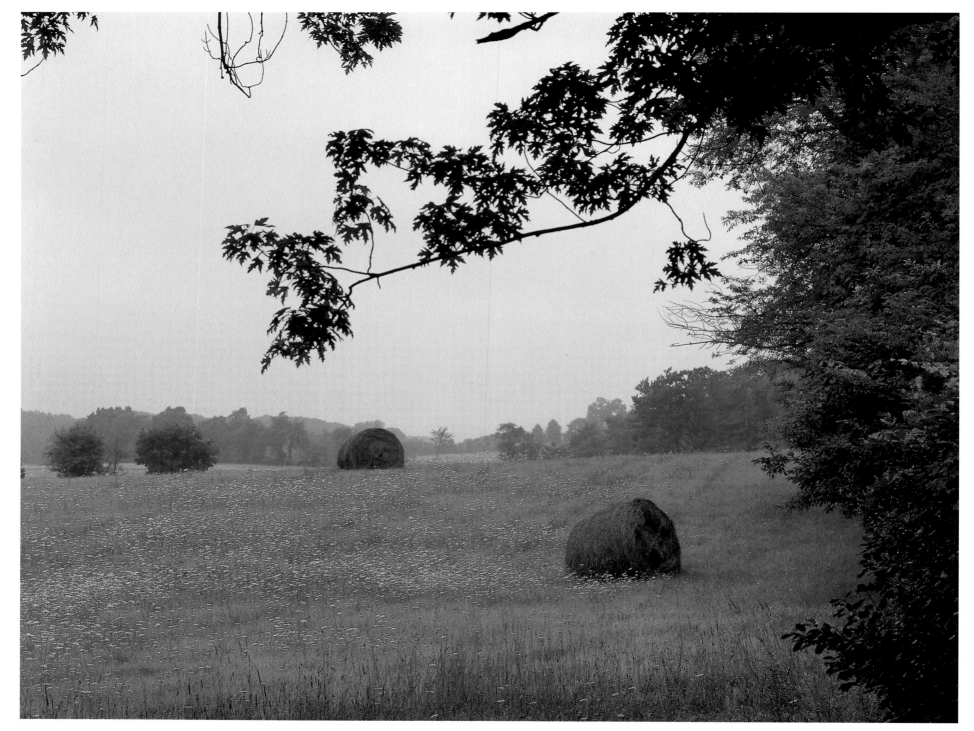

Summer Harvest

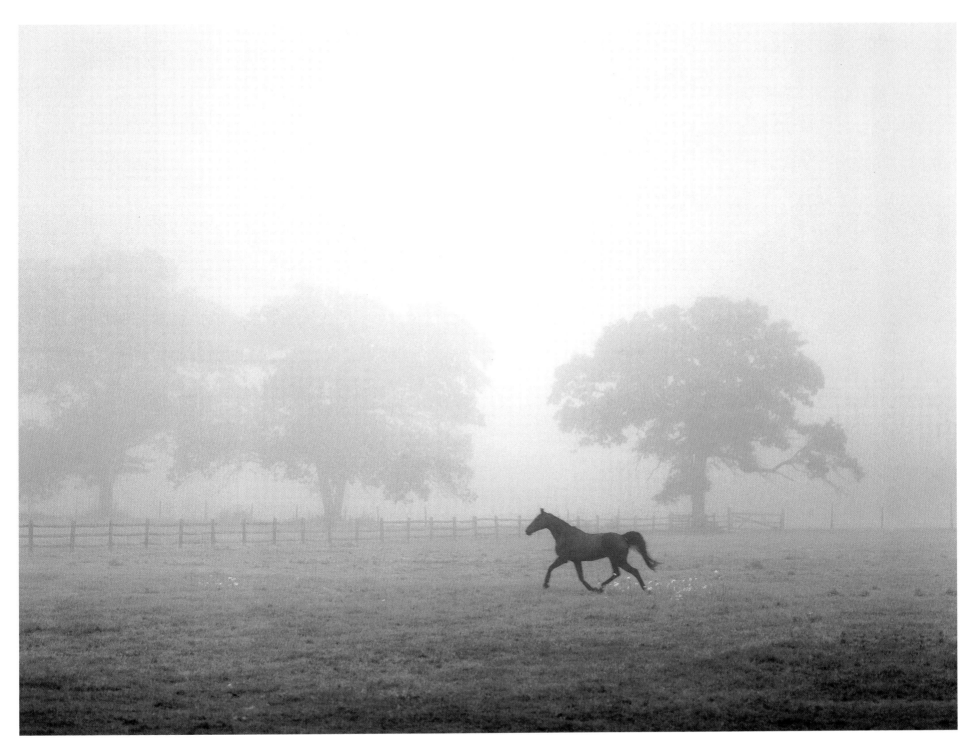

Waldingfield Farm. *I do not know the name of this horse. I don't know much about horses, but this horse is no nag.*

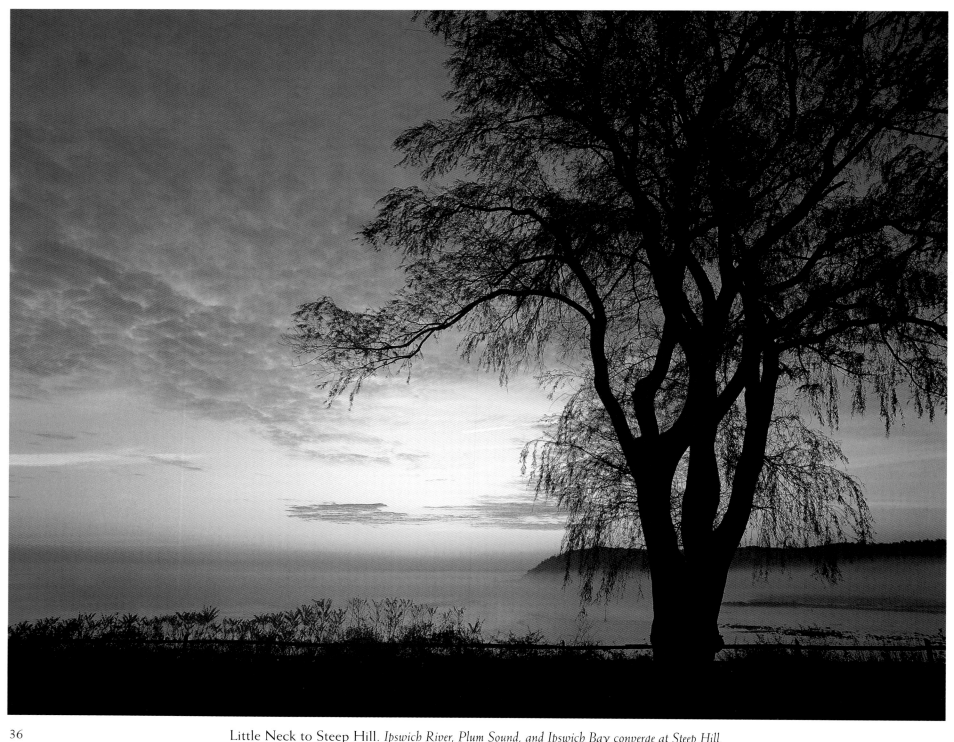

Little Neck to Steep Hill. *Ipswich River, Plum Sound, and Ipswich Bay converge at Steep Hill.*

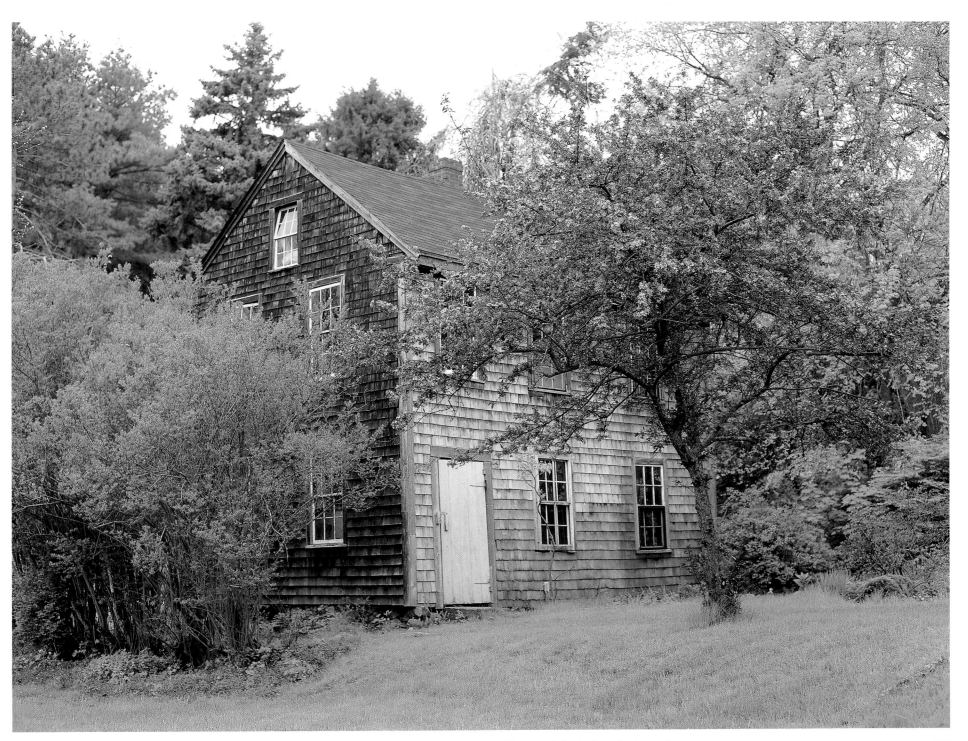

East Street Barn. *Every time I pass this small barn, I feel a little rush of nostalgia.*
As a boy, I had the whole upstairs of a barn like this to myself. No other real estate from that time gave me such joy and contentment.

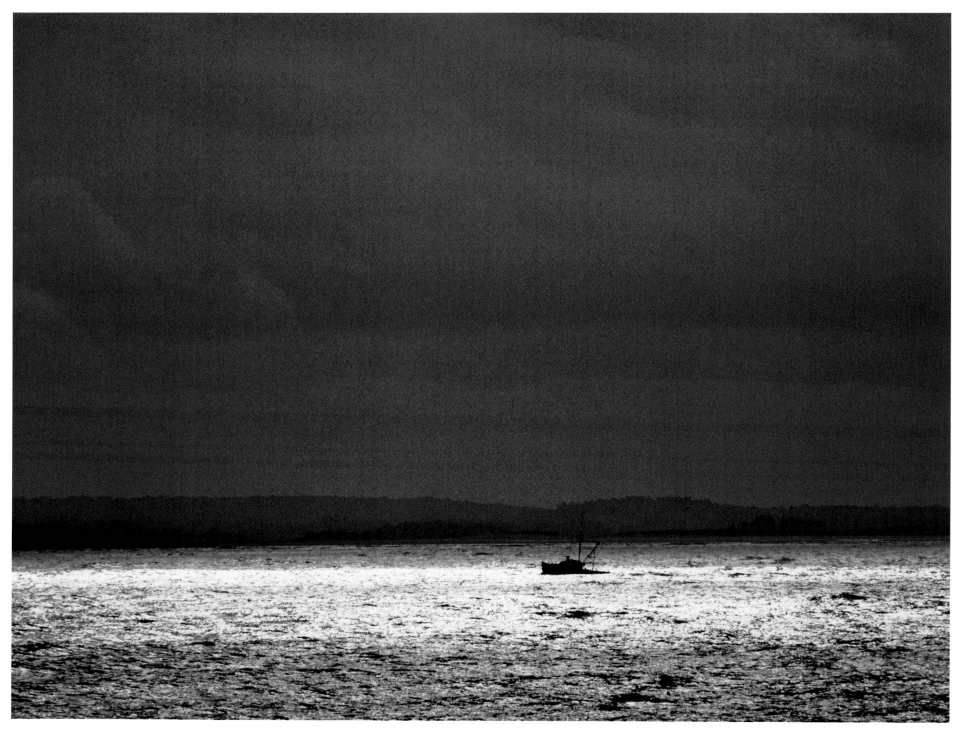

Running Home before the Storm. *A commercial fisherman on Ipswich Bay.*

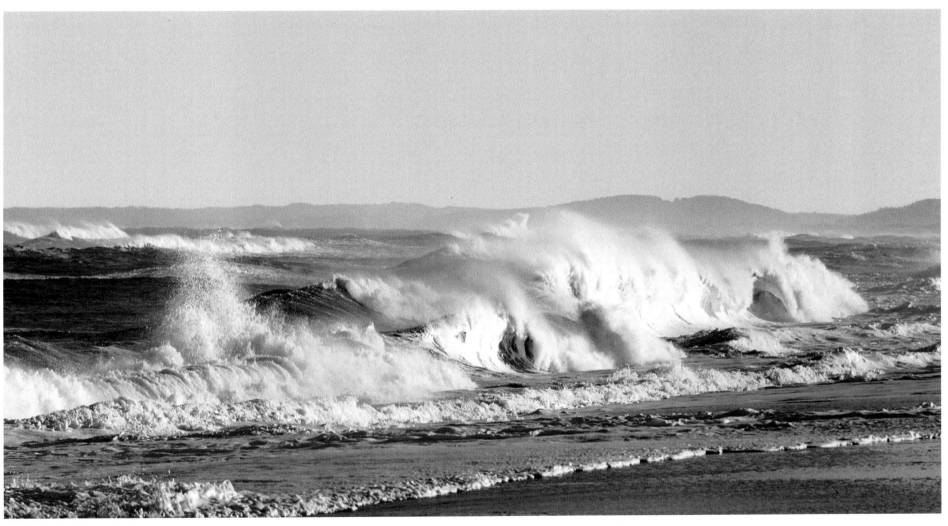

Dancing Surf. *In January, the sun rises in line with the surf of Plum Island. The dip in the crown of Choate Island can be seen ten miles away.*

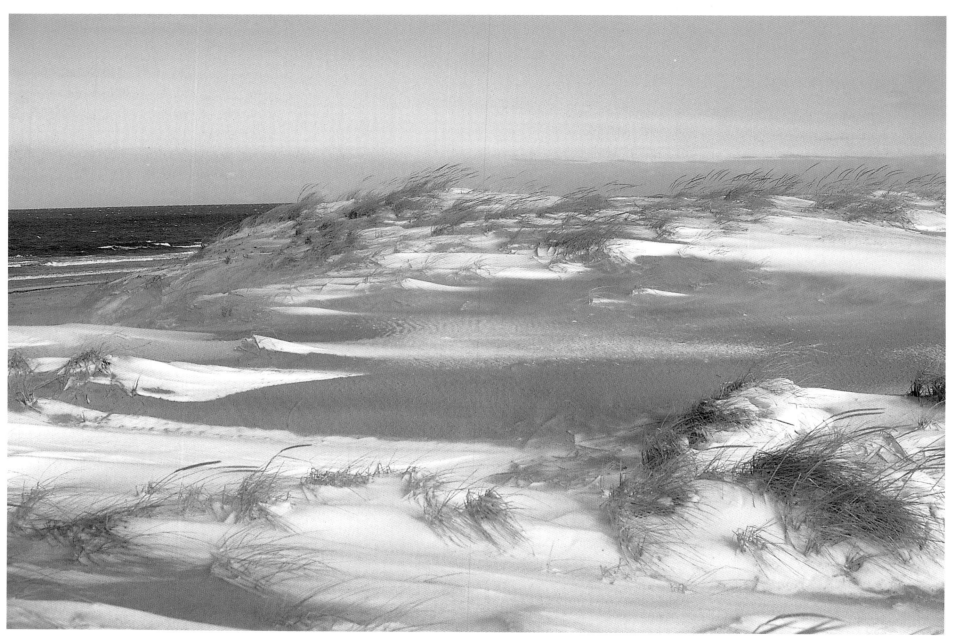

Crane Beach, Winter

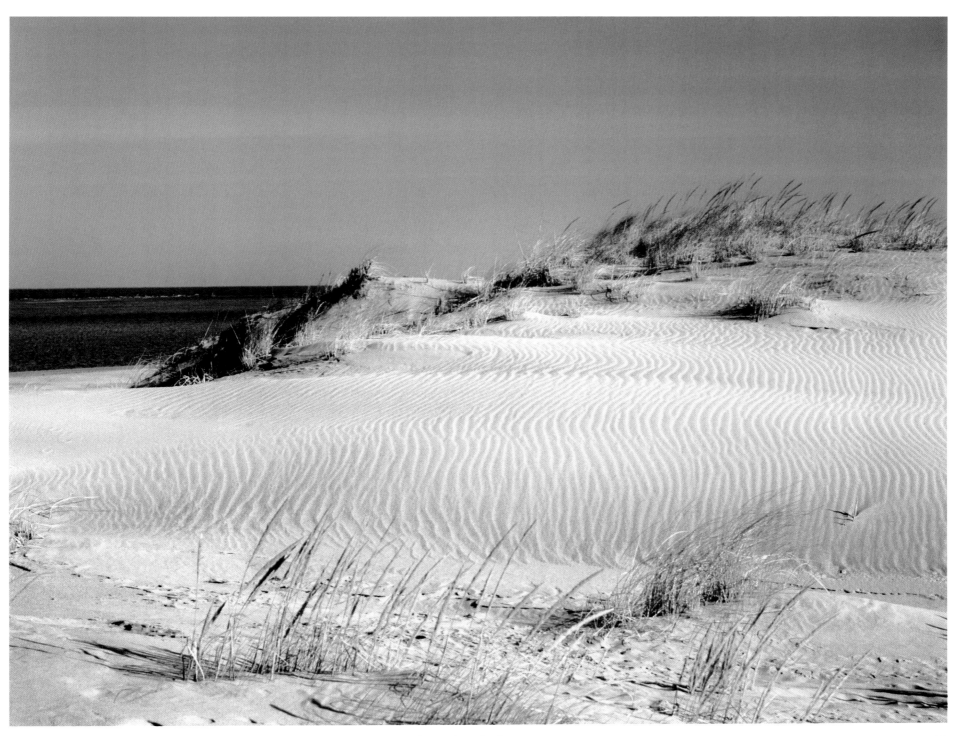

Crane Beach, Summer

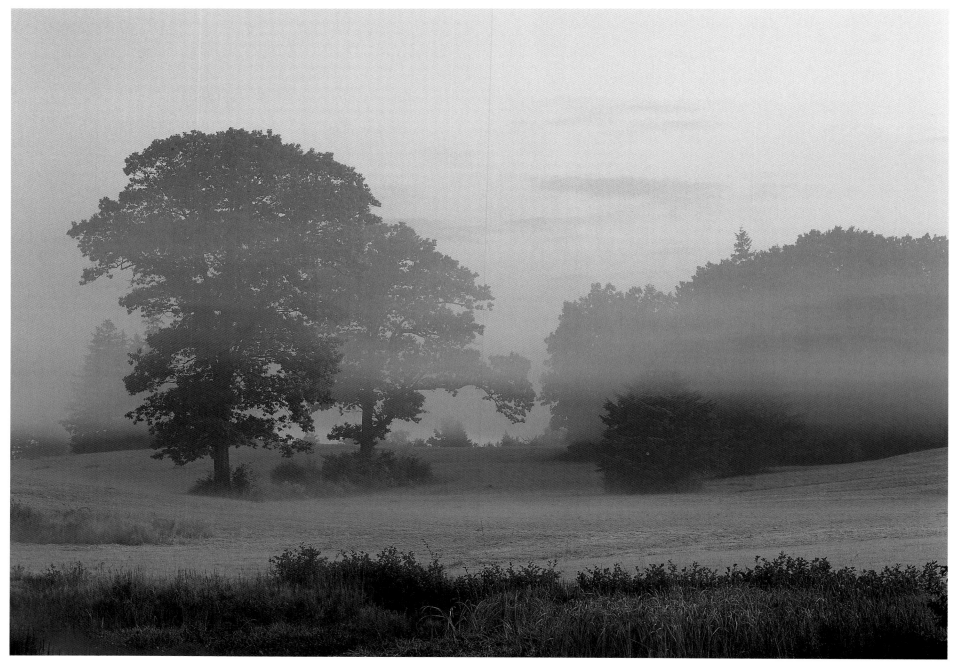

Morning Fog

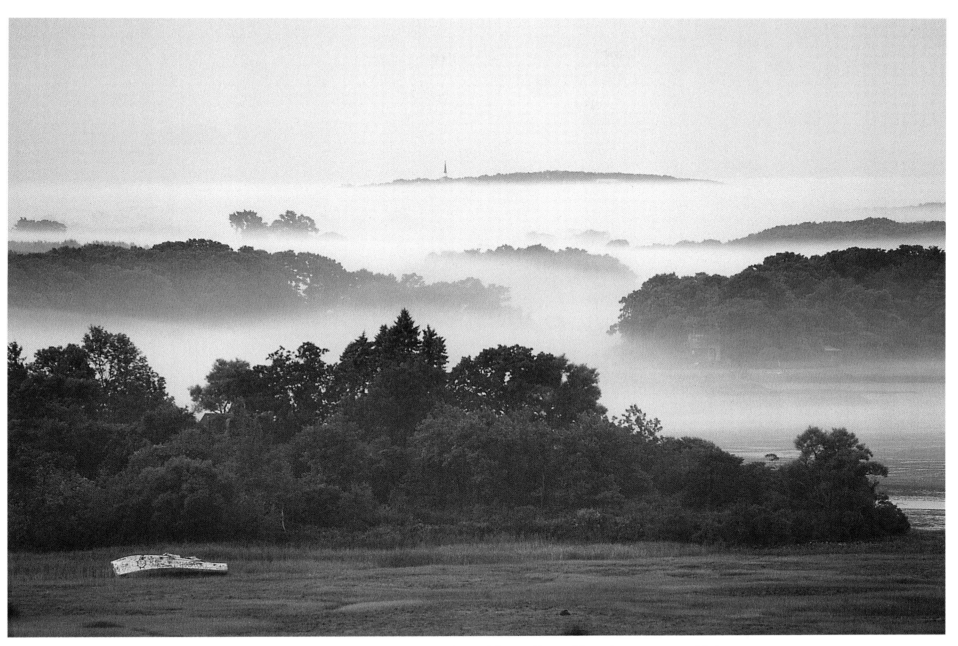

Fog on the Salt Marsh. *Ever changing, always different. Ghosts of Ipswich past appear and fade.*

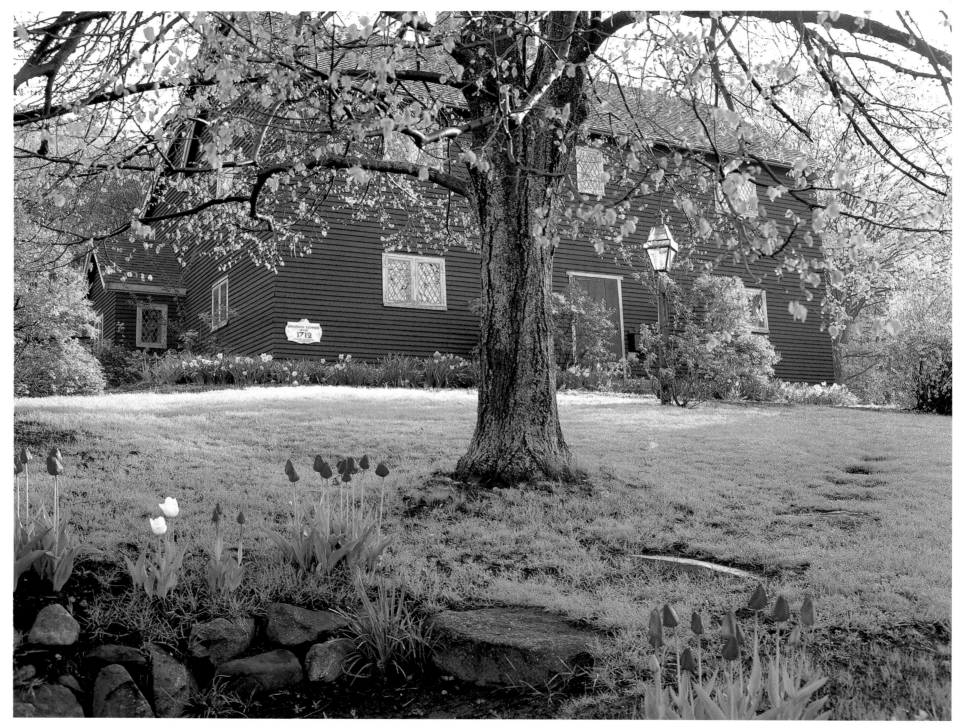

Jonathan Lummus House, 1712

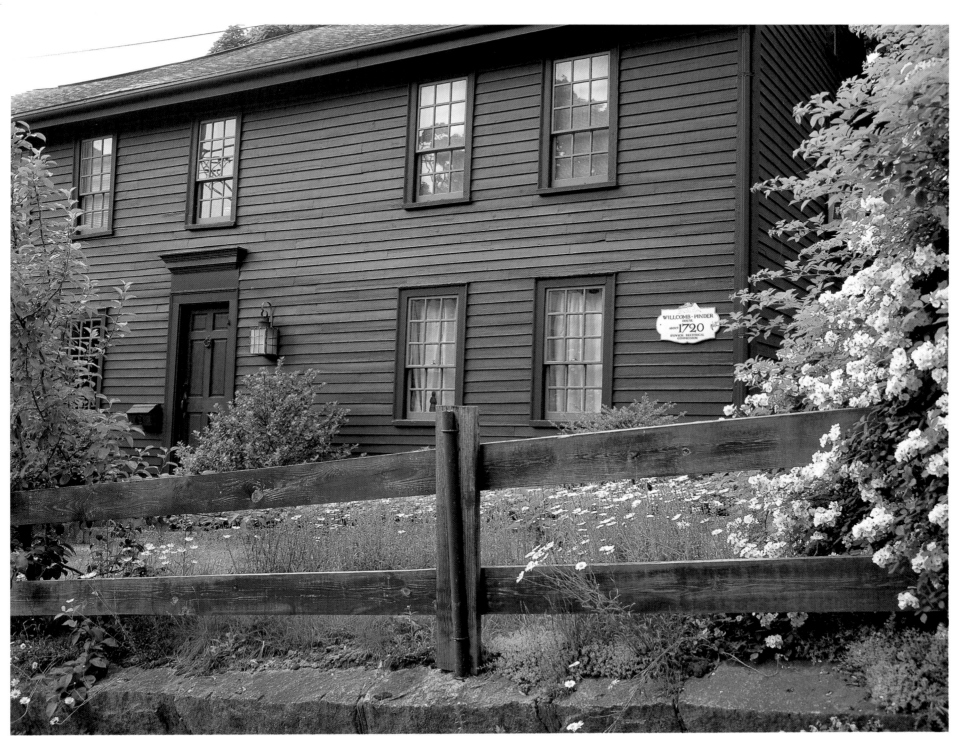

Willcomb-Pinder House, circa 1720

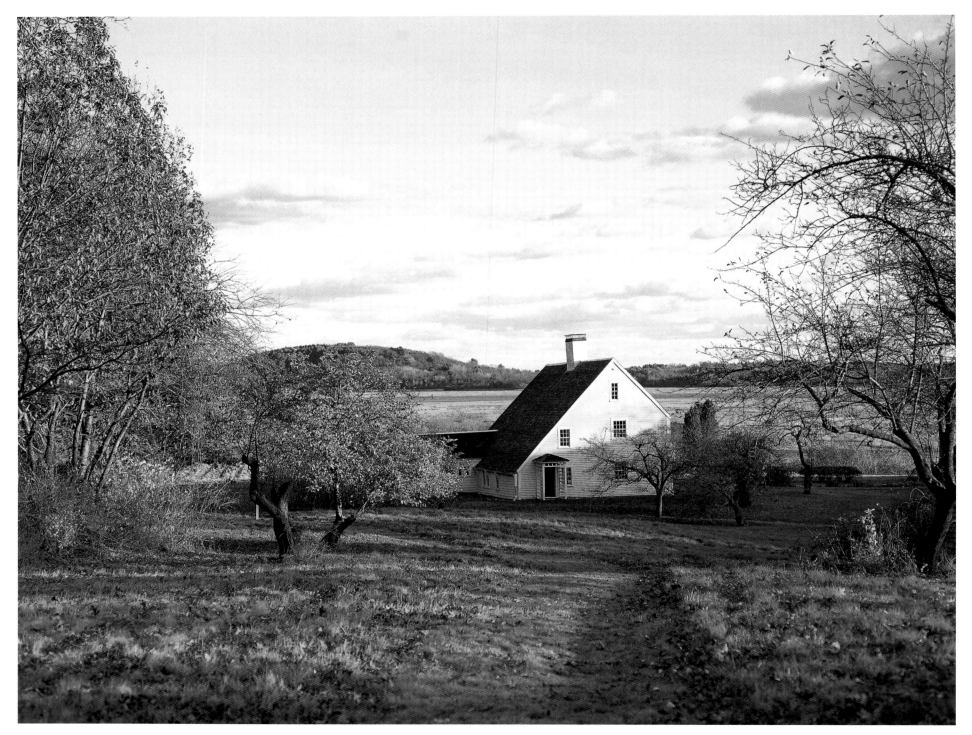

Greenwood Farm, Paine House, circa 1702

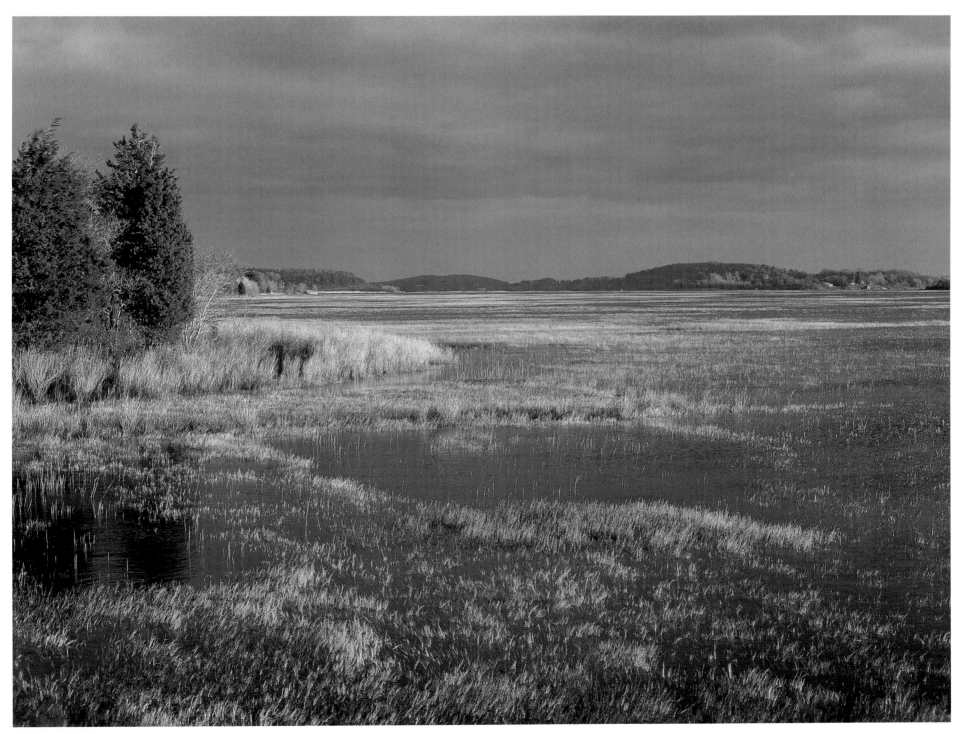

Great Neck Marsh, Autumn. *I have learned that every scene has its moment. The trick is being there.*

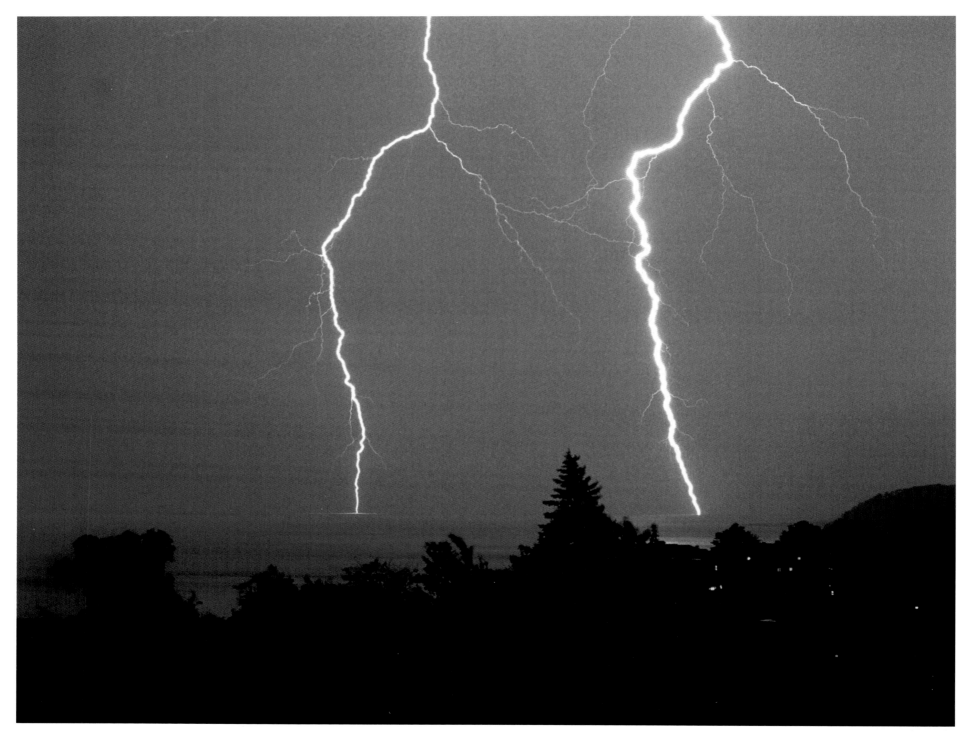

Lightning over Ipswich Bay

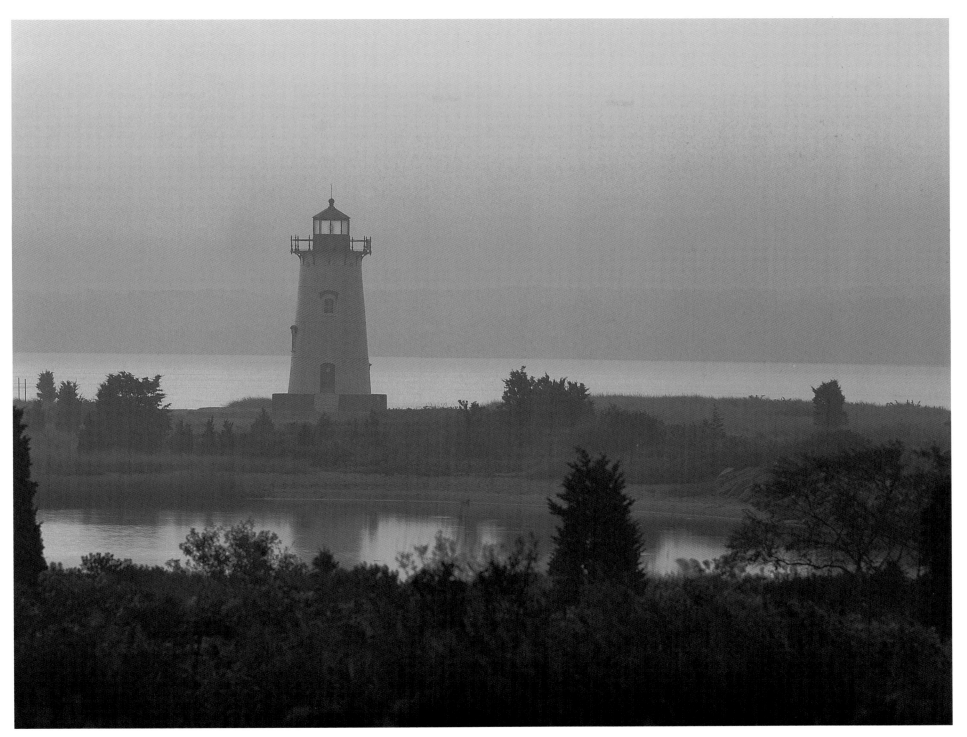

Old Ipswich Light. *What's the true story behind the Ipswich Light caper of 1938? On Martha's Vineyard, they now call it Edgartown Light, but we in Ipswich know better.* 49

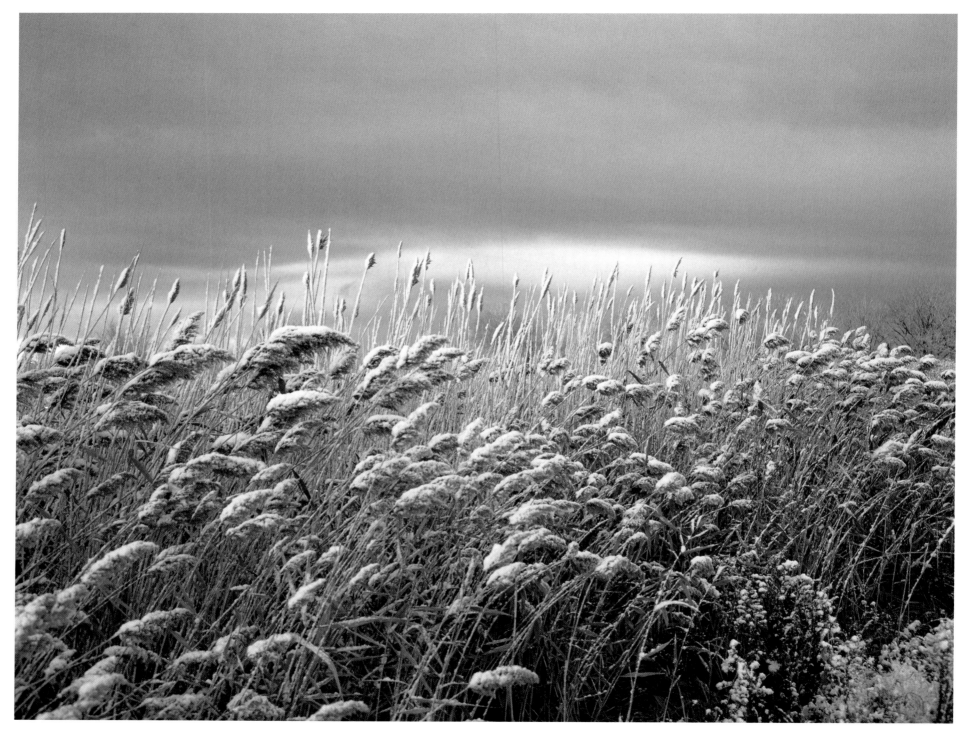

Winter Solstice

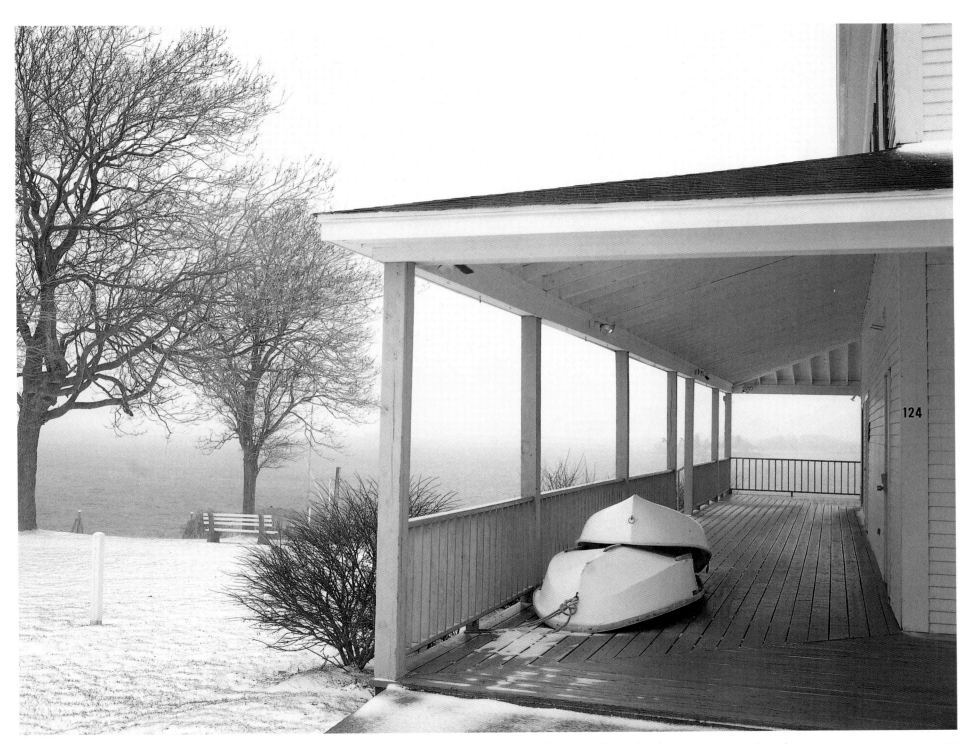

Ipswich Bay Yacht Club, Winter. *Walking around the yacht club in February, I always feel that winter is a month too long.*

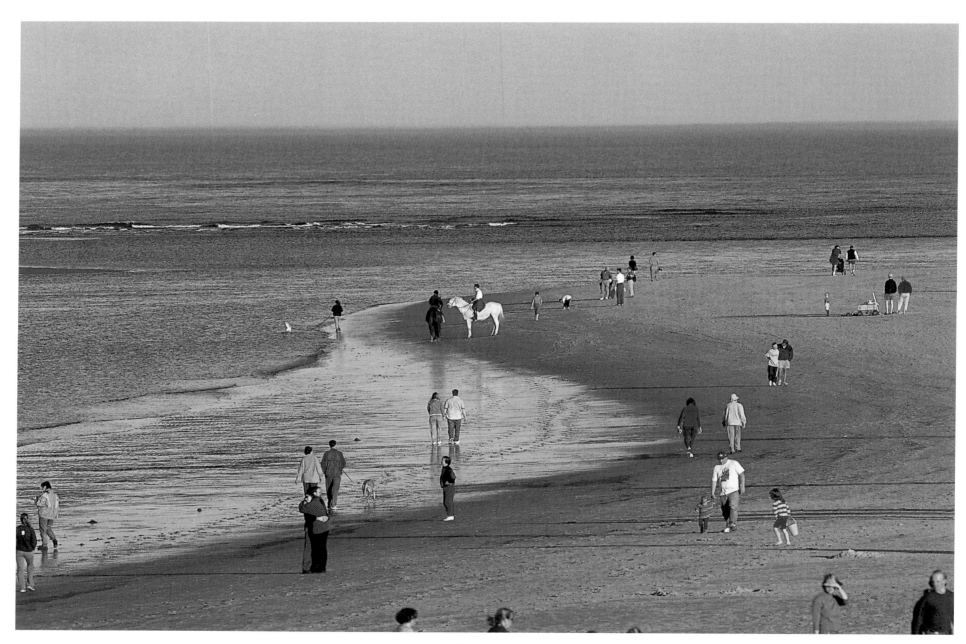

January Thaw, Crane Beach

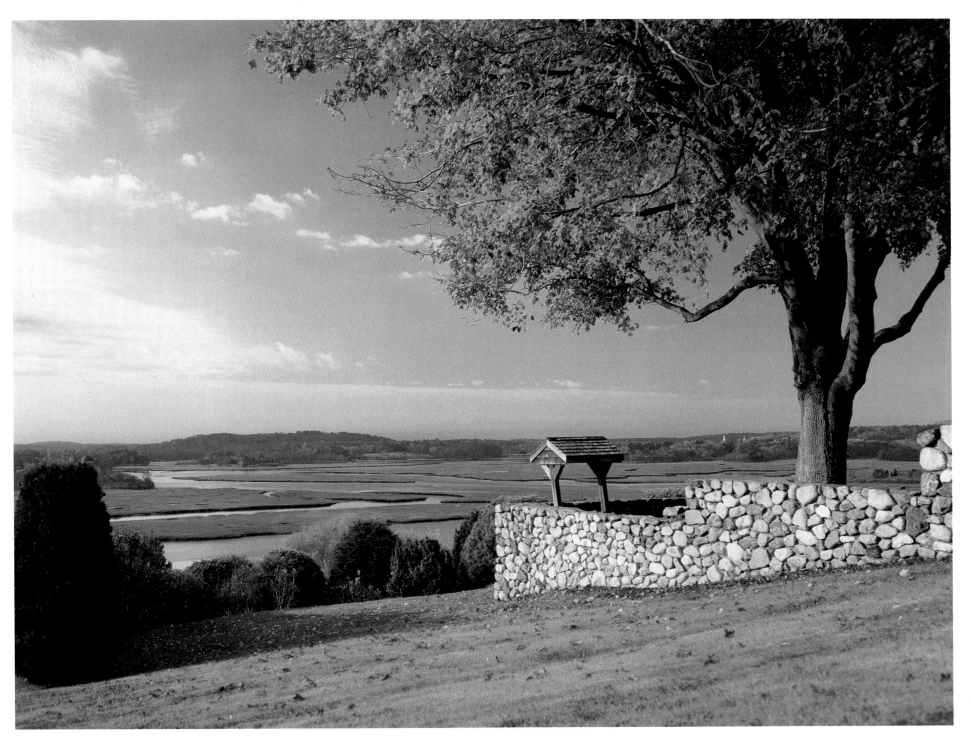

Bunker Hill to Town Hill Steeples. *A visitor to my gallery once said,*
"What we love about New England is that, when we see a steeple rising above the trees, we know that somewhere beneath it lies a town."

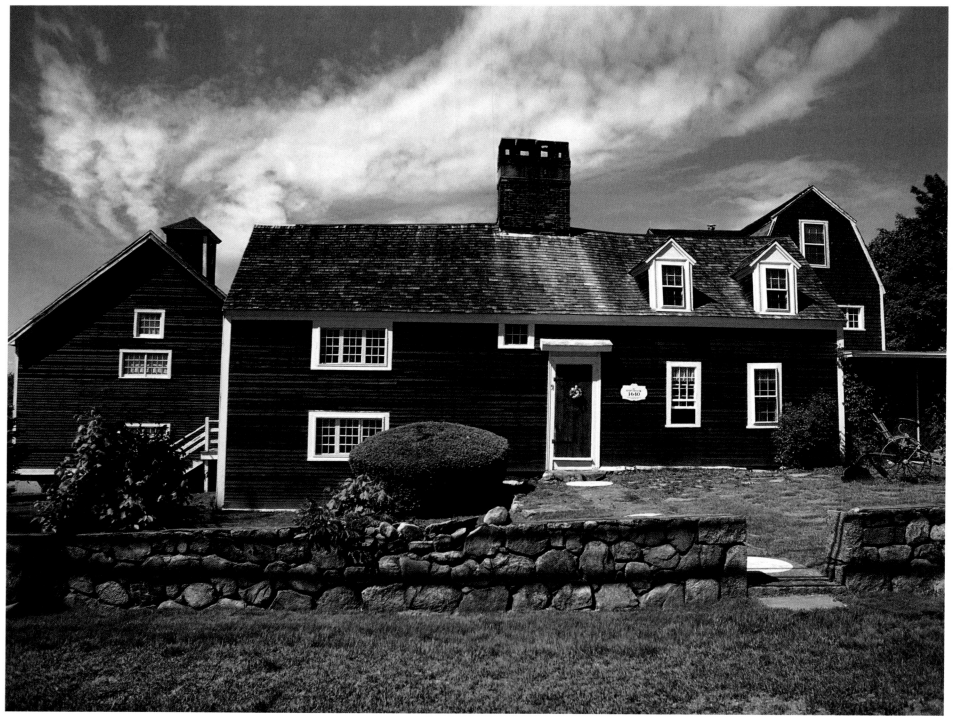

Hart House, 1640

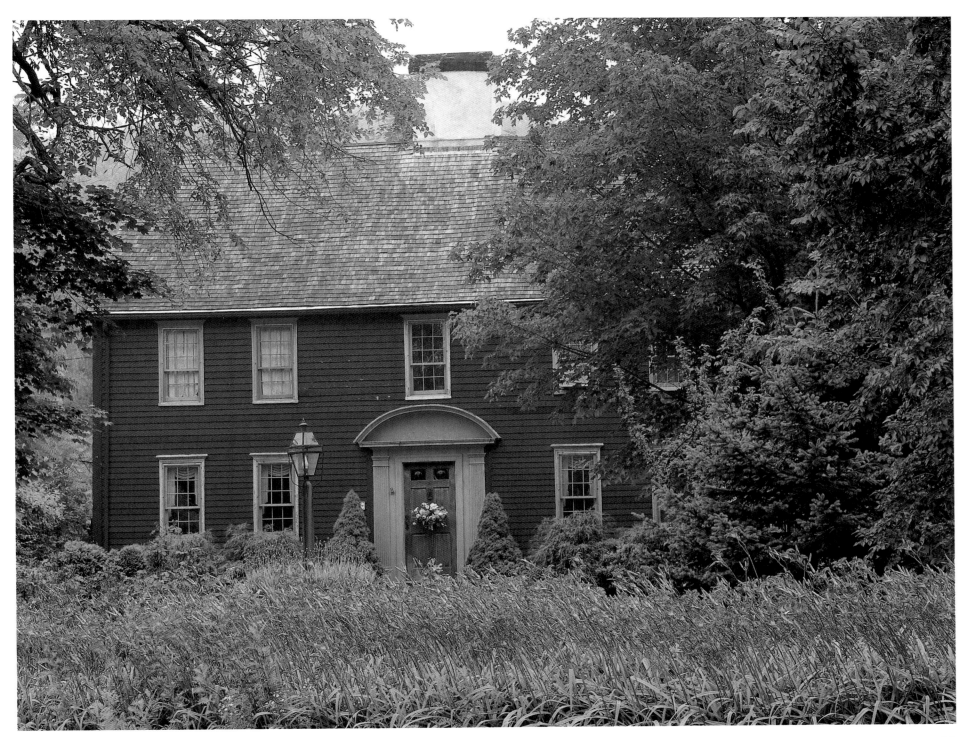

Capt. Moses Jewett House, 1759

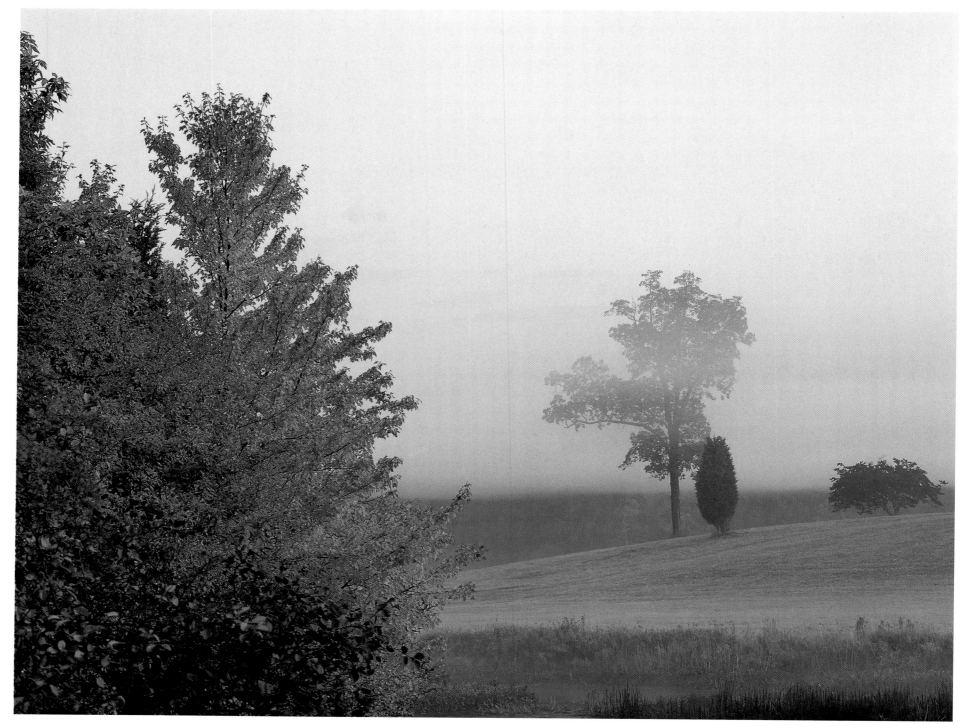

Touch of Autumn. *Sometimes less is more.*

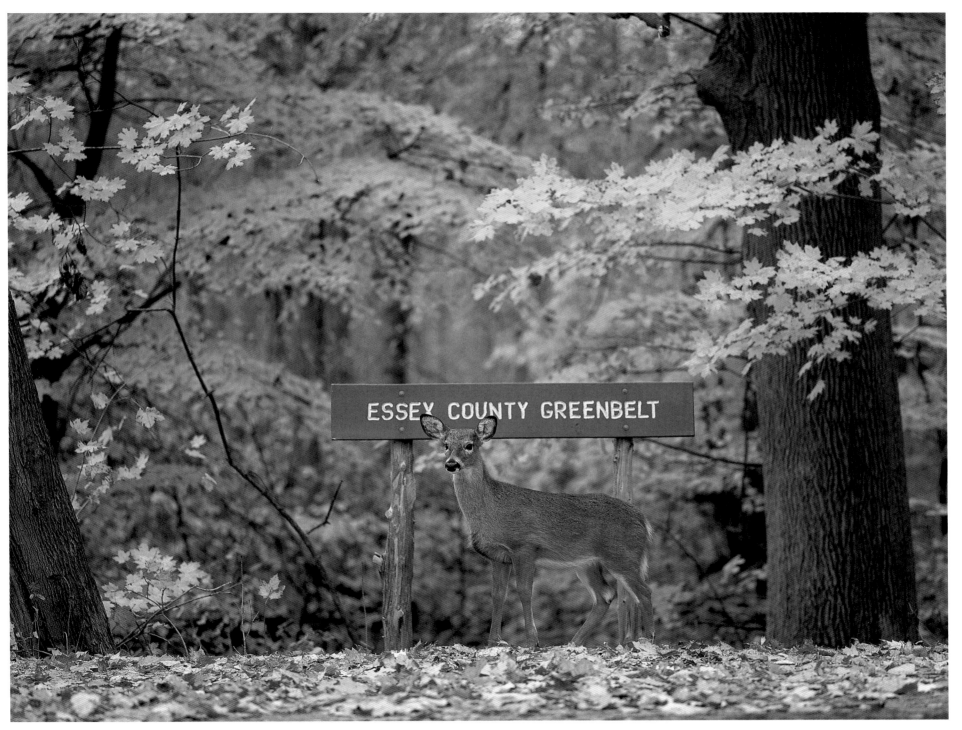

Pricket. *I was setting up a tripod when a young male deer walked out of the forest toward me. For a moment, I was spooked.* 57
He acted like a friendly dog. I later learned that the deer had a name, Oliver, and that his mother had been killed by a car. He learned to survive on his own, fearlessly.

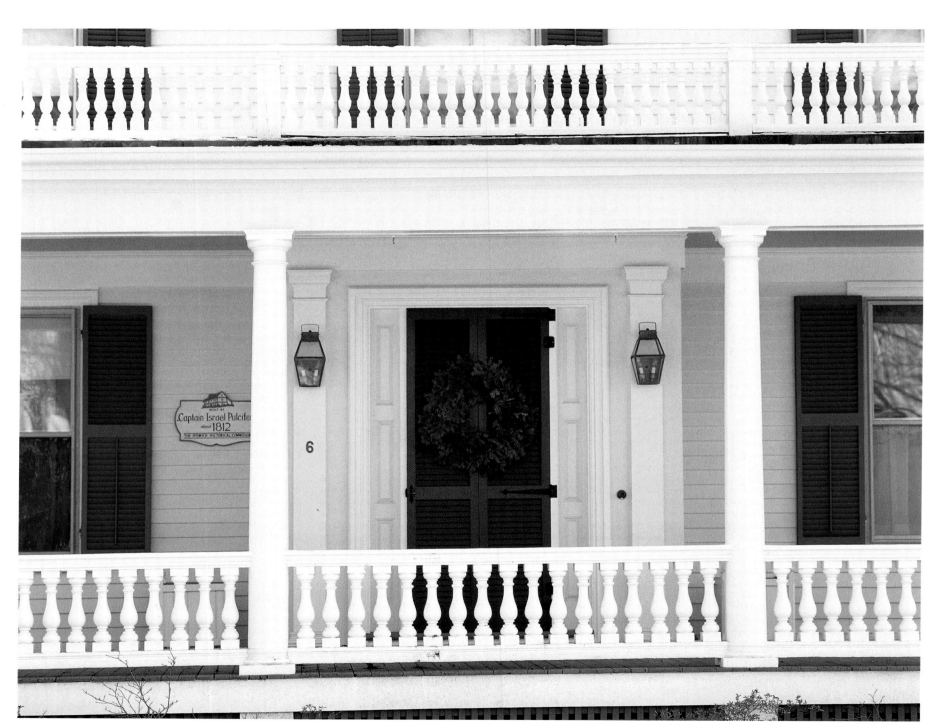

Capt. Israel Pulcifer House, circa 1812

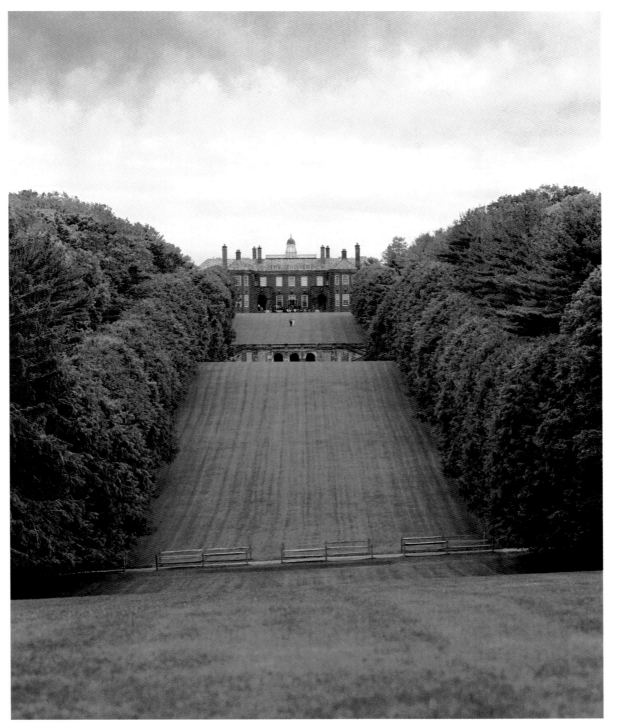

Wedding at The Great House. *I was invited to a wedding at Castle Hill.*
With hand signals over a great distance, my wife orchestrated this shot. The shoot took less than a minute, while the round-trip walk took an hour.

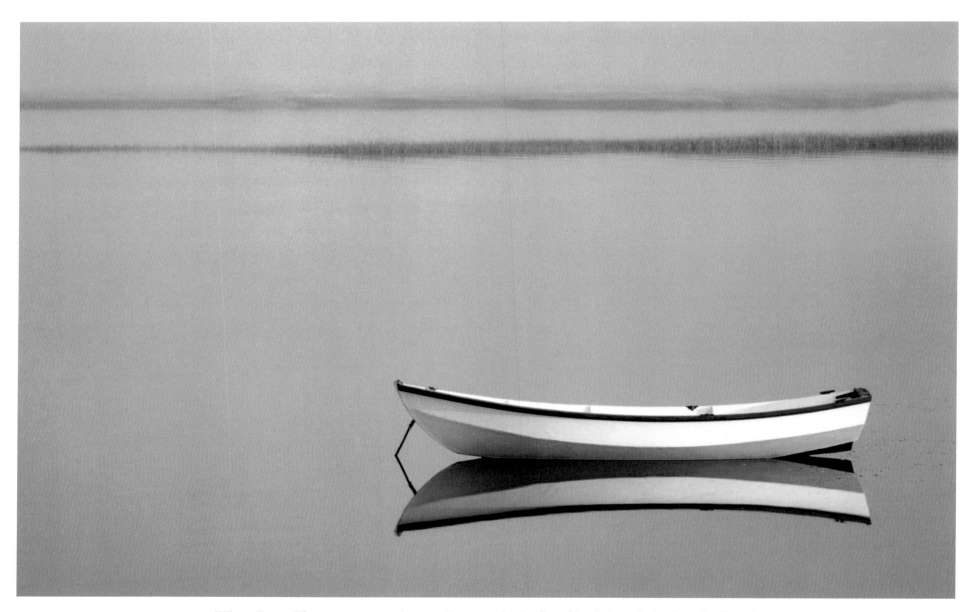

White Dory. *This mirror image took time and patience. It's the effect of low light, a slack tide, and still wind.*

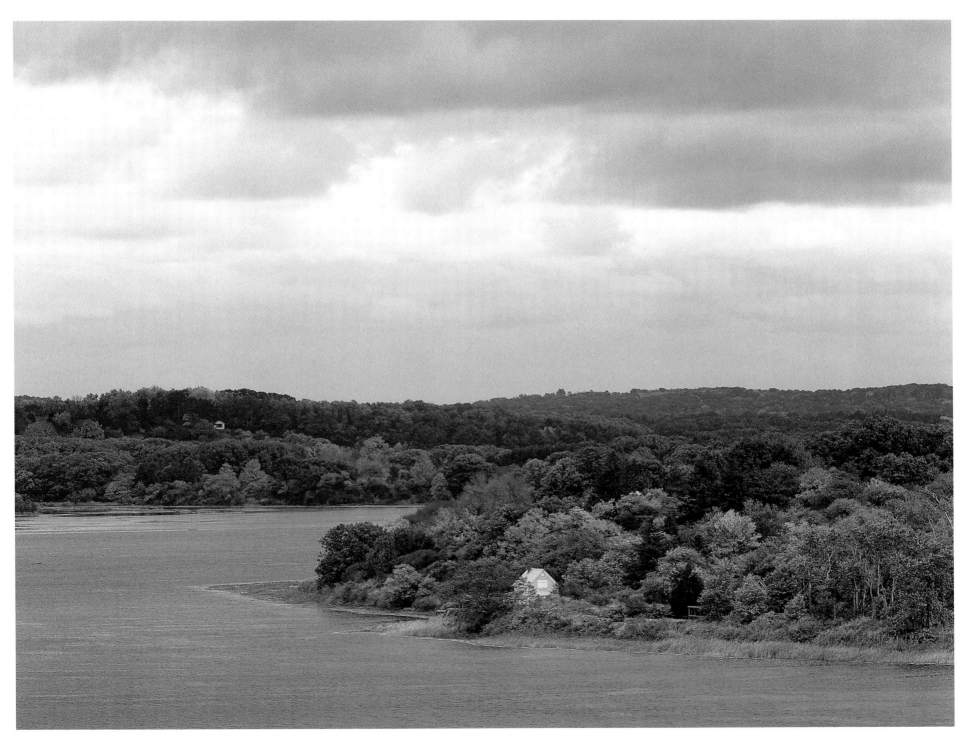

Treadwell Island. *Tranquility and serenity on the Ipswich River.*

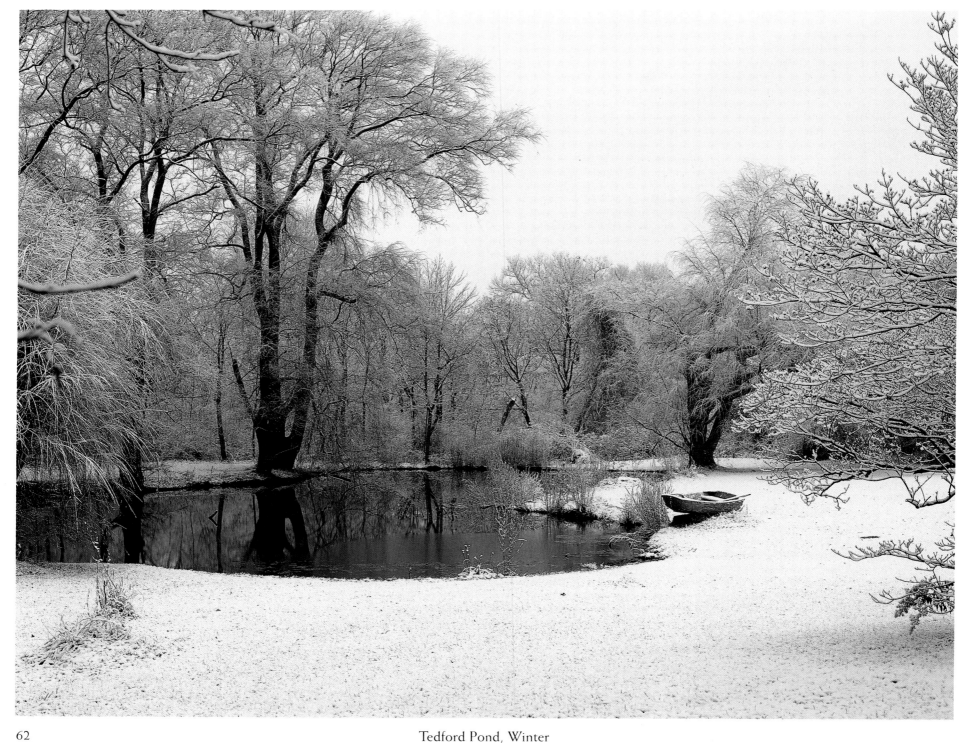

Tedford Pond, Winter

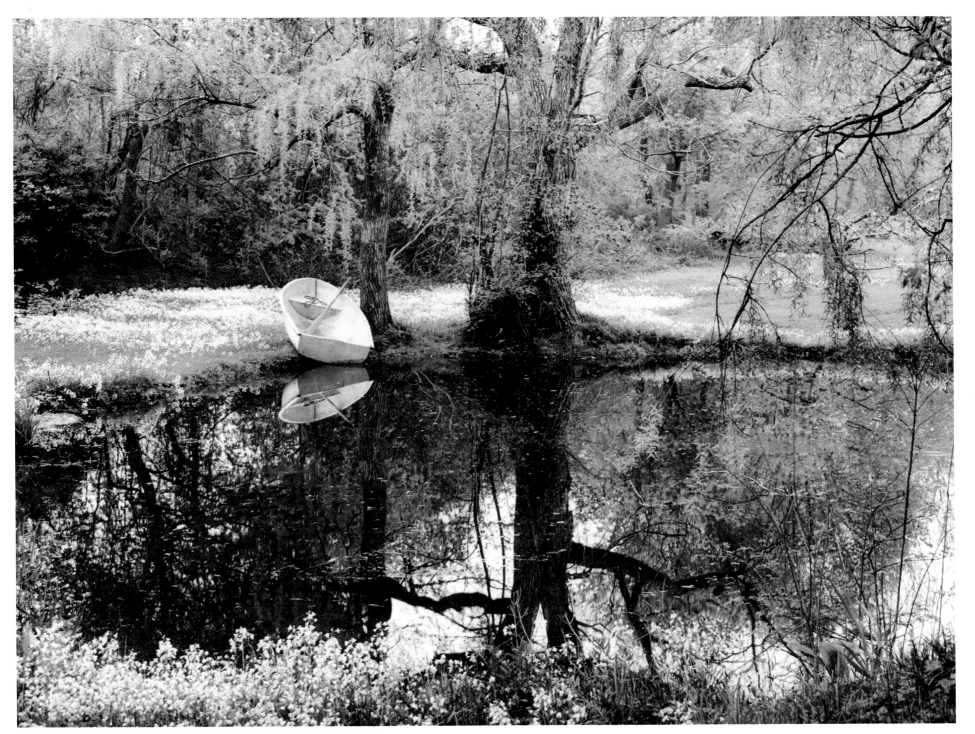

Tedford Pond, Early Spring

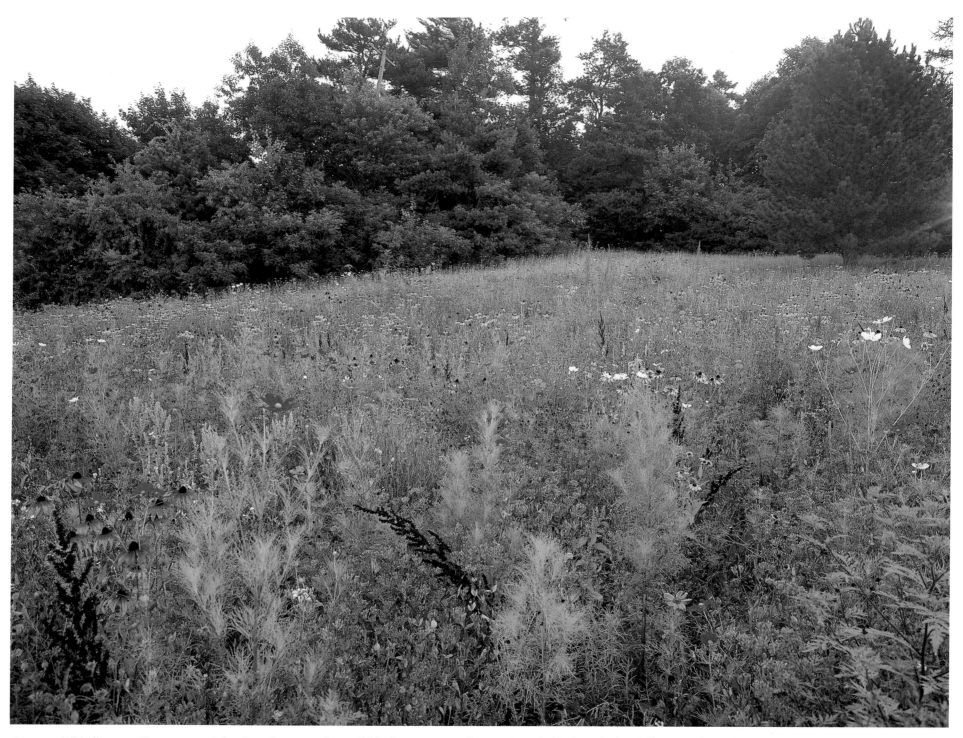

64 Wildflowers. *Every now and then I get the urge to do a still life. I was scooping flowers along the Neck road when Officer Rausher pulled his cruiser alongside and said,*
"Don't you know you need a permit to do that?" I looked back with a blank expression. He laughed and drove away. I like a cop with a sense of humor.

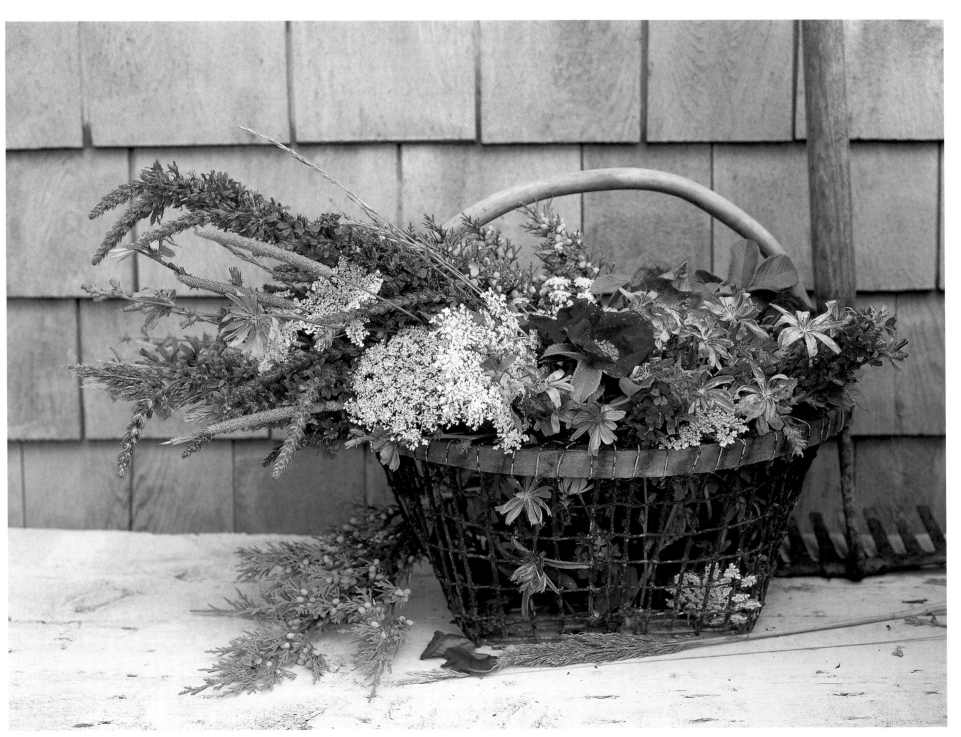

Old Clam Basket with Wildflowers

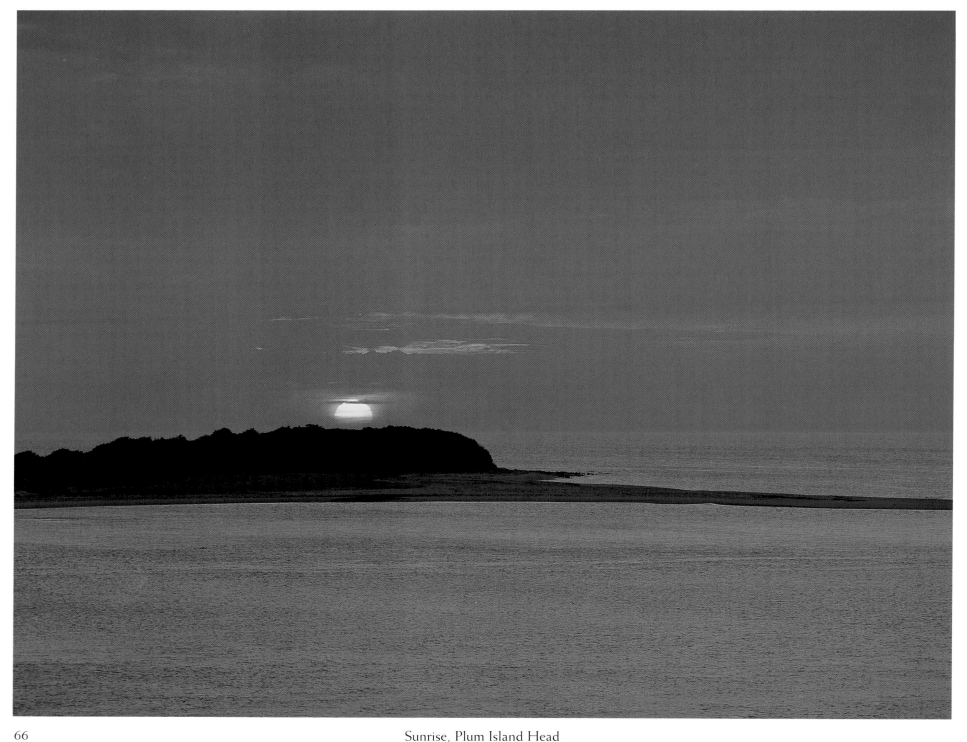

Sunrise, Plum Island Head

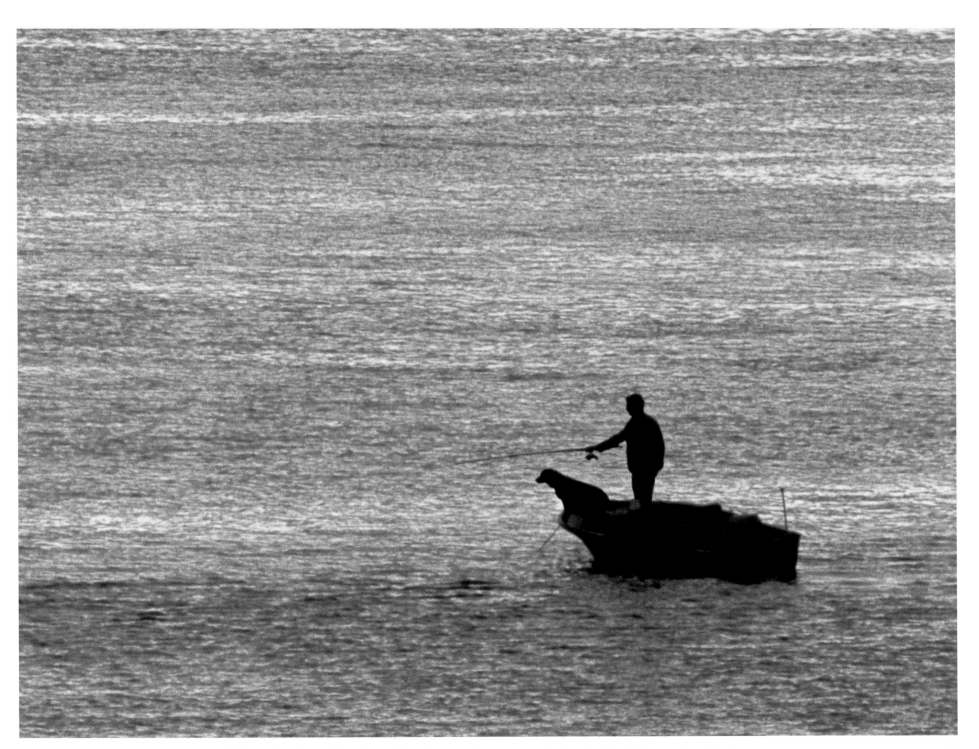

Fishing Buddies. *When the rod dipped and the line went taut, the dog barked with joy and anticipation.*

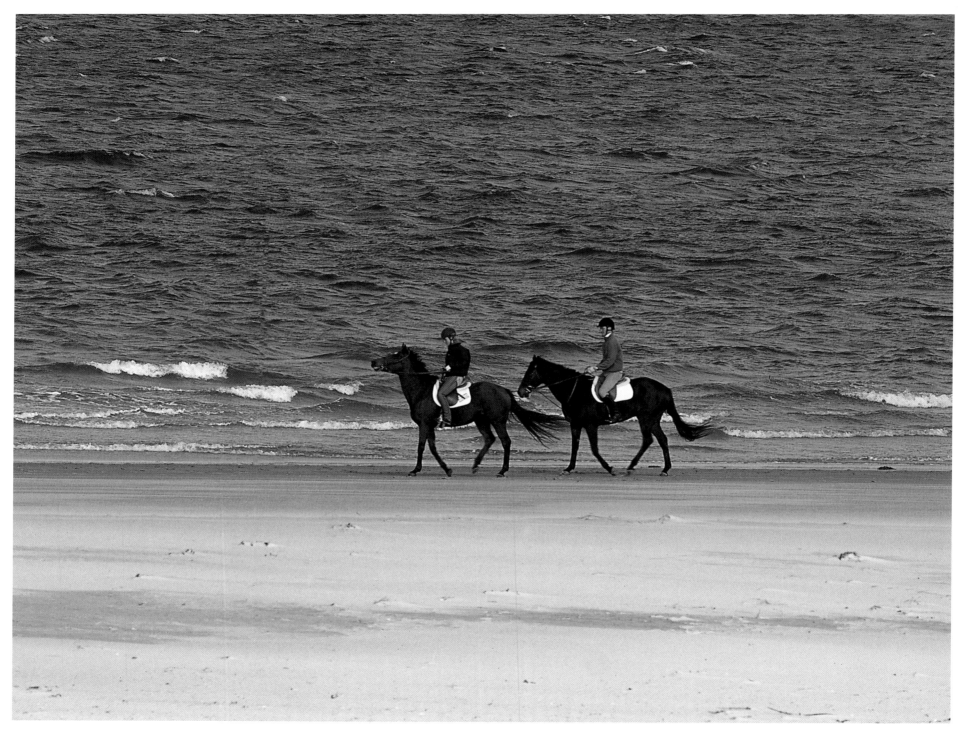

Beach Riders. *I don't know who is enjoying themselves more, the horses or their riders.*

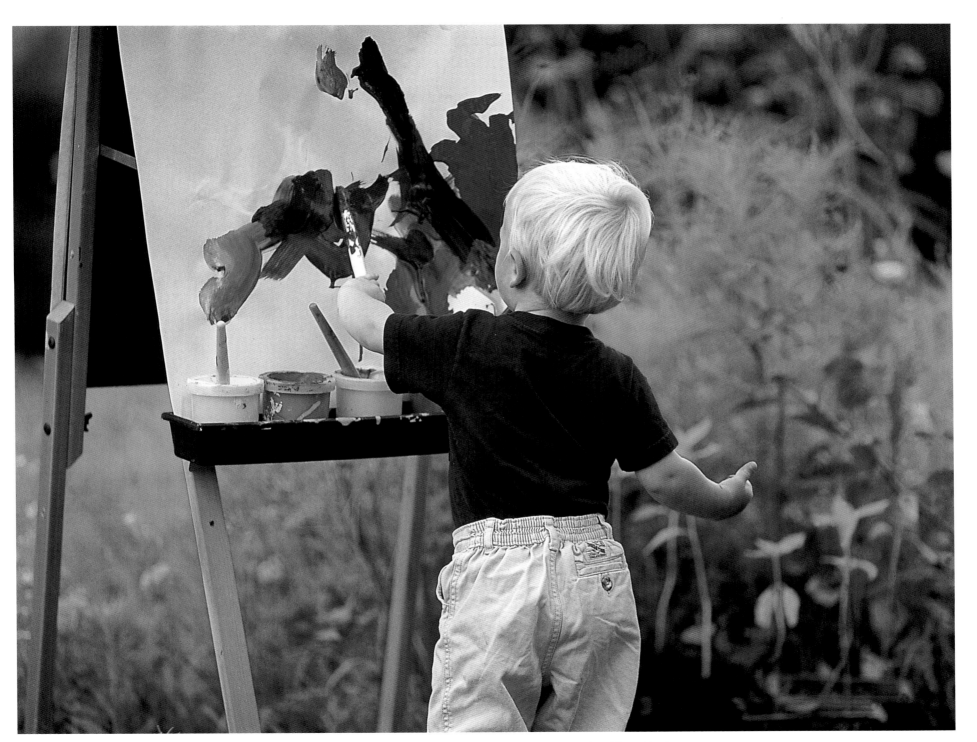

Sam. A young Ipswich artist with a "just do it" attitude, unintimidated by a blank canvas.

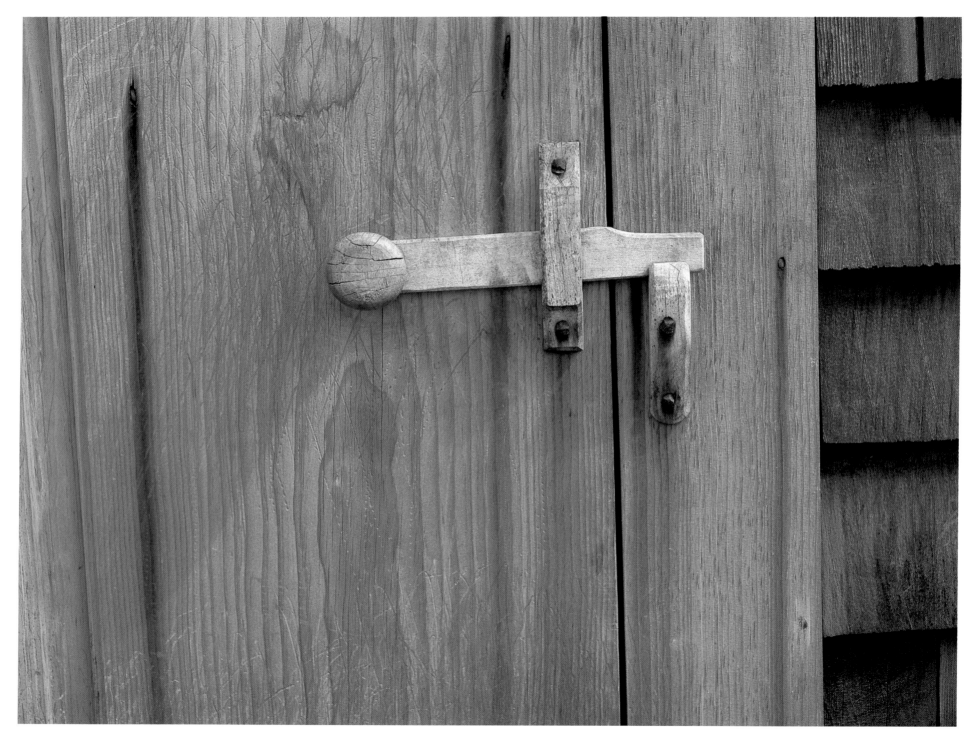

The Latch. *Back door to the Benjamin Grant House—simplicity, function, craft.*

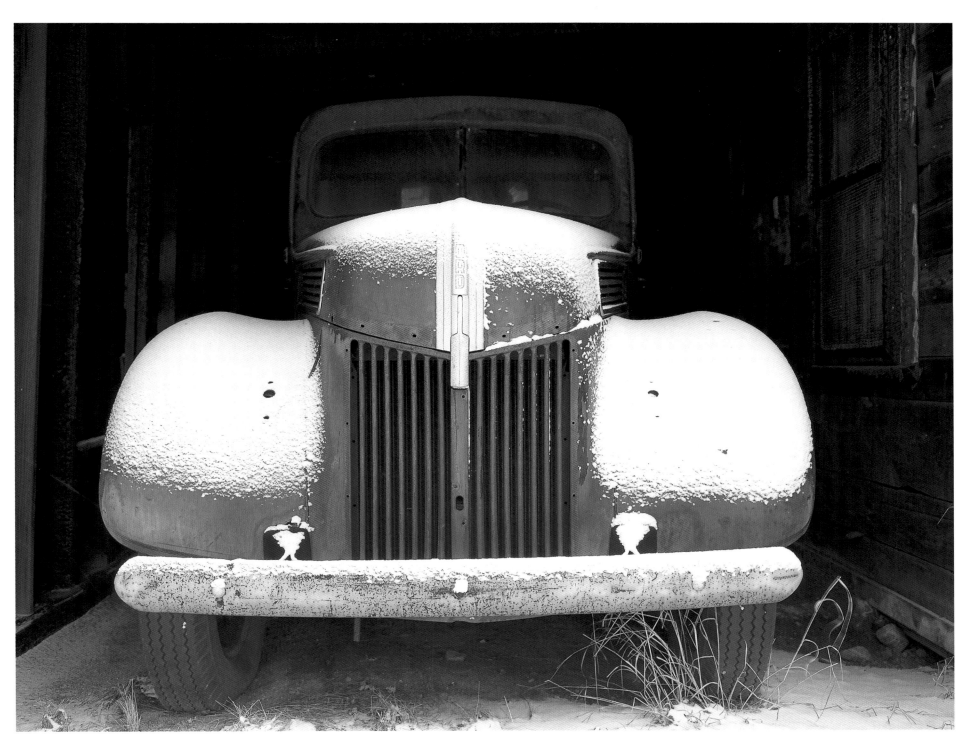

Old Ford. *I could not drive down Route 133 without another look at the old Ford.*
Then, one day, she was gone. A year later, I still look into the vacant void, wondering her fate.

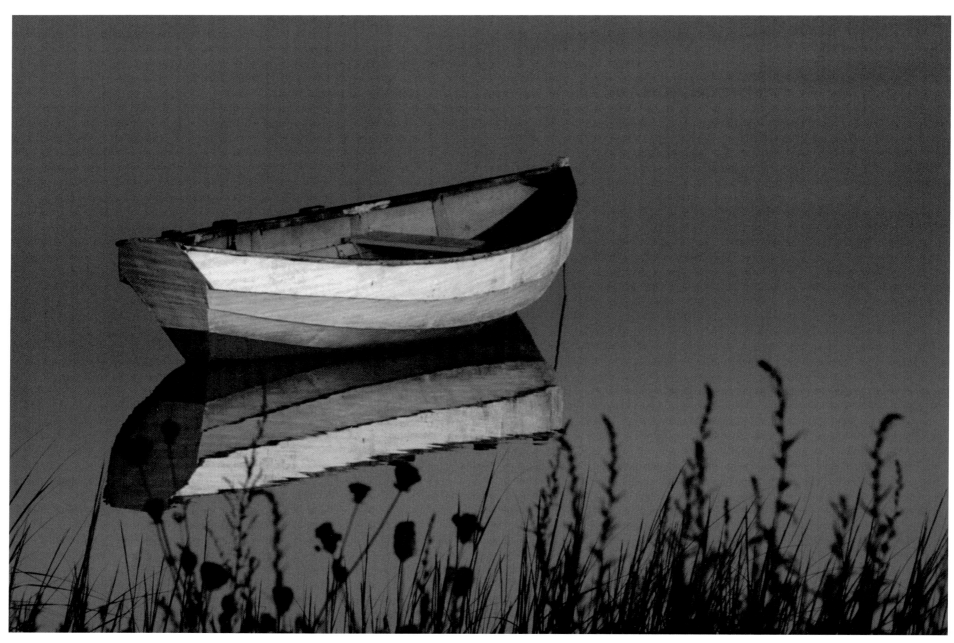

Yellow Dory. *I think of author Kitty Robertson and her love of boats. Only a dory can be painted yellow and look just right.*

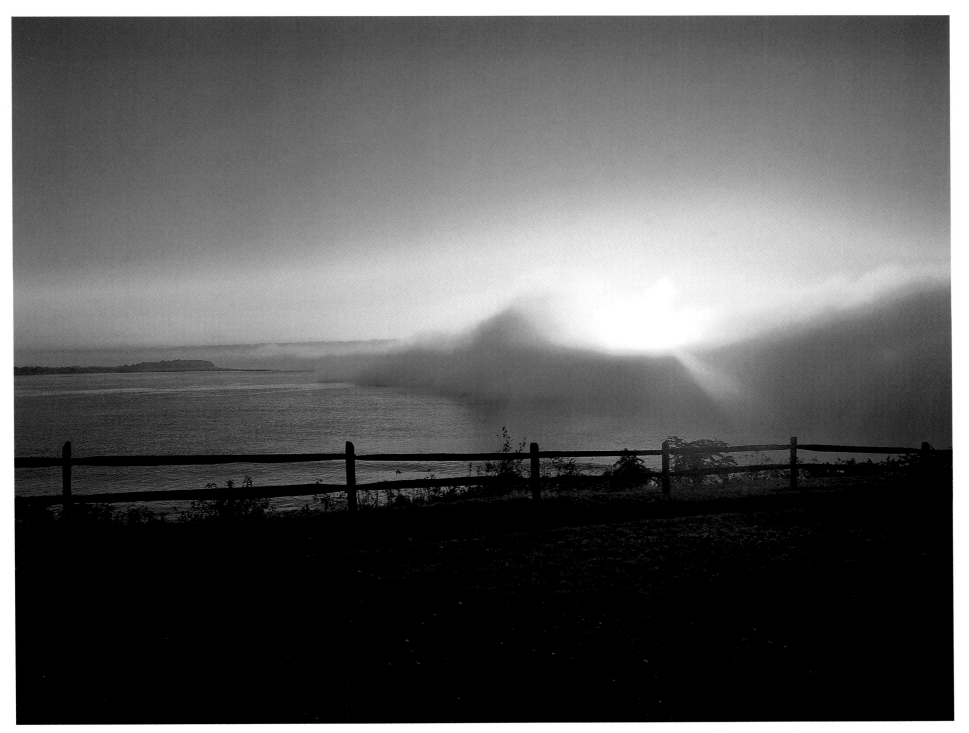

Fog Bank at Sunrise. *This was a pleasant surprise—catching the sun just as it spilled over the fog bank. One second later, it was a blow-out.*

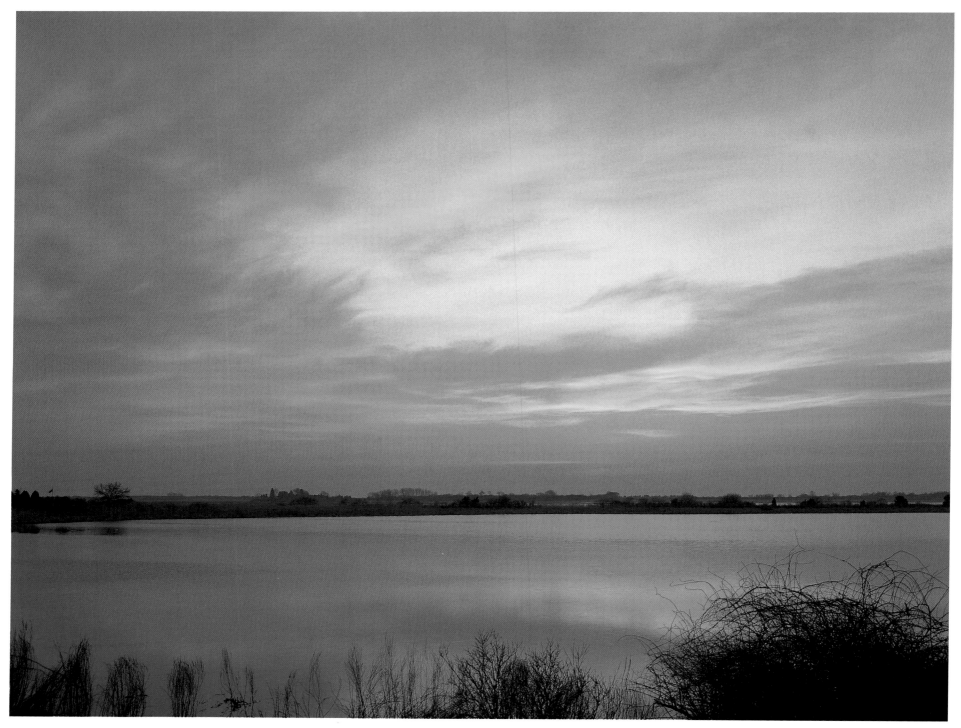

Dawn, Clark Pond. *Once a shooting gallery for wild birds, now a sanctuary for the same.*

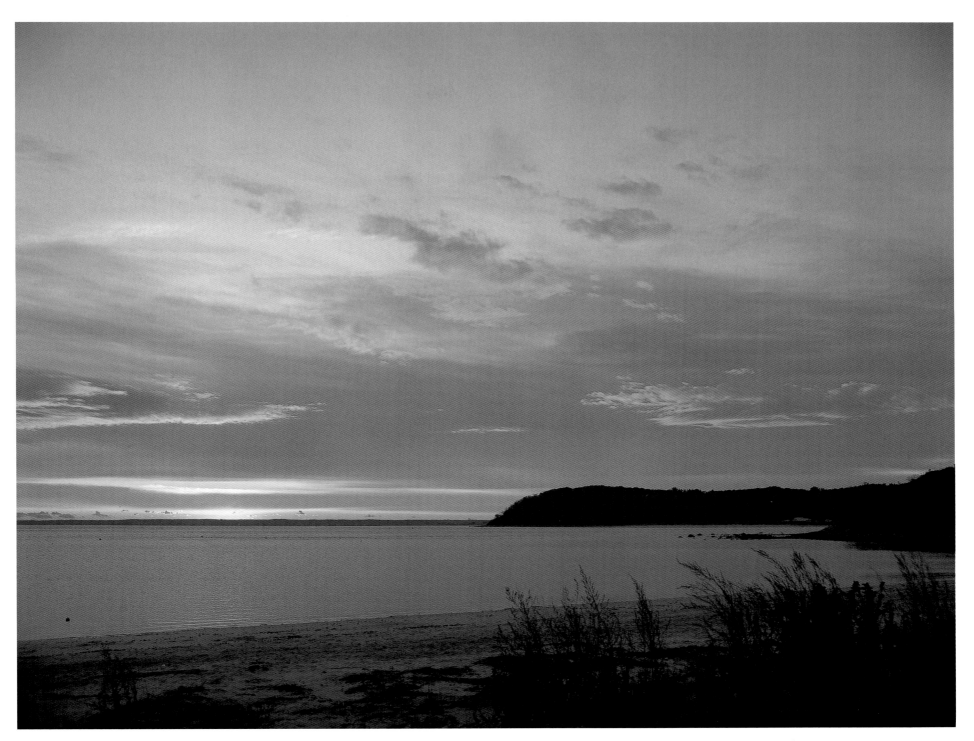

From Pavilion Beach. *The pavilion was destroyed in the blizzard of 1978, and we got back the view we had always missed.*

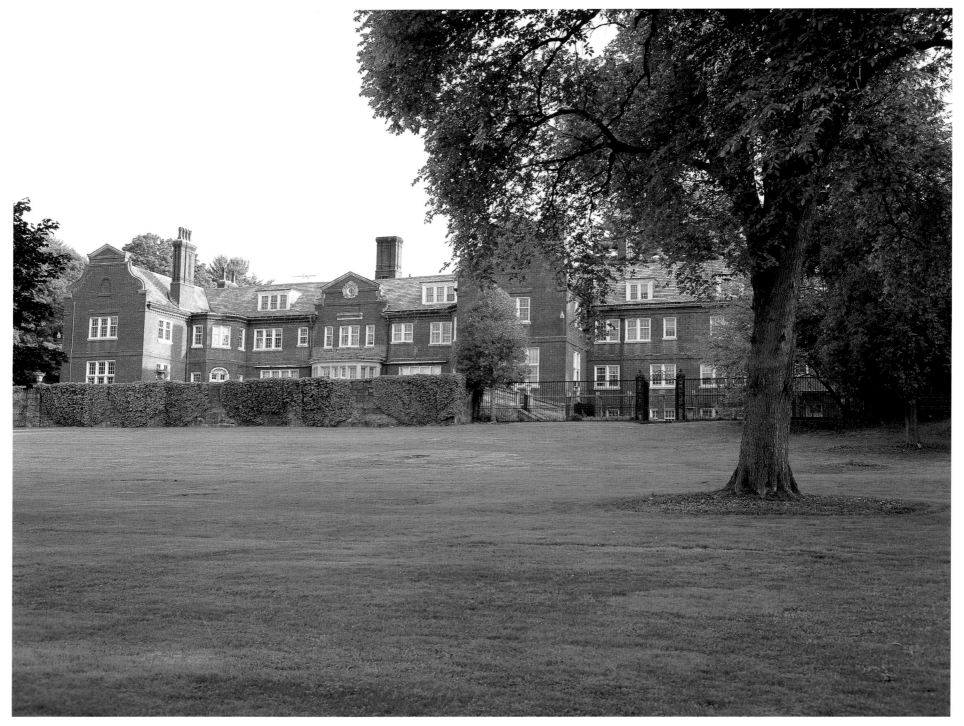

The Mansion at Turner Hill

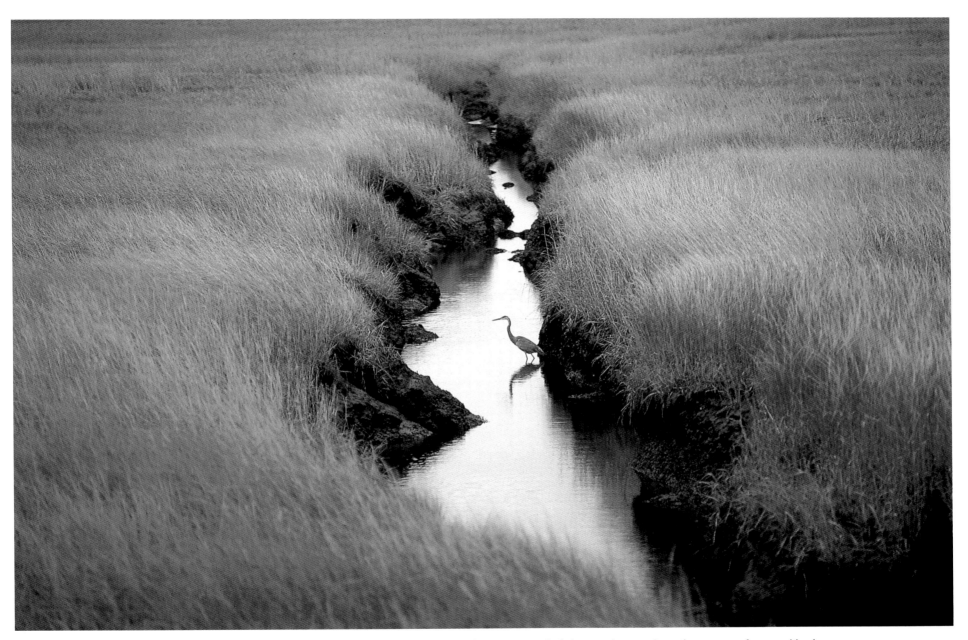

Fox Creek. *You don't want to be caught here on a falling tide. It's a long wait in a little boat, unless you have the patience of a great blue heron.*

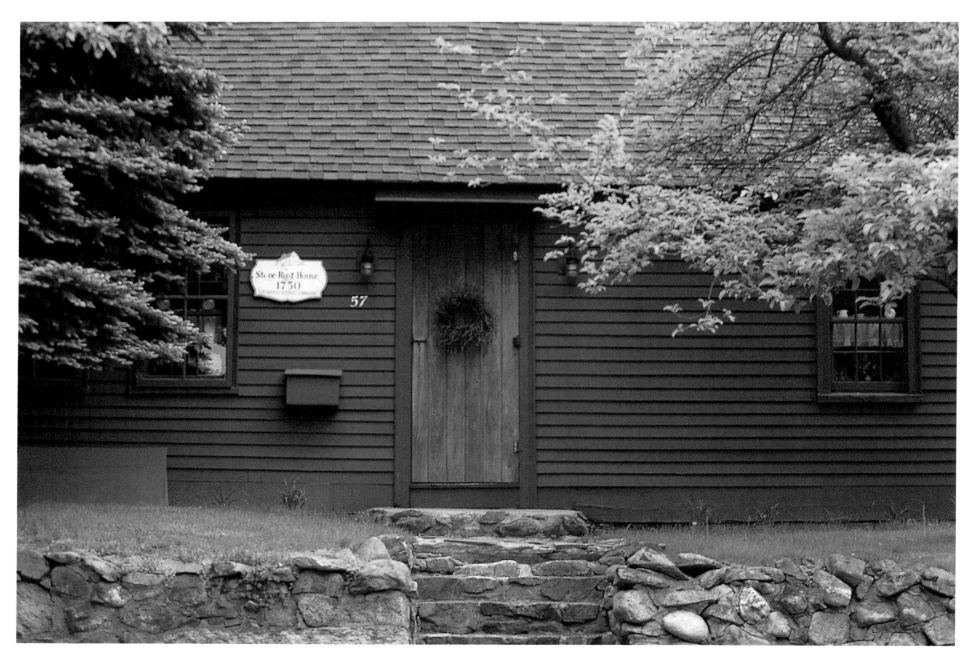

Stone-Rust House, circa 1750

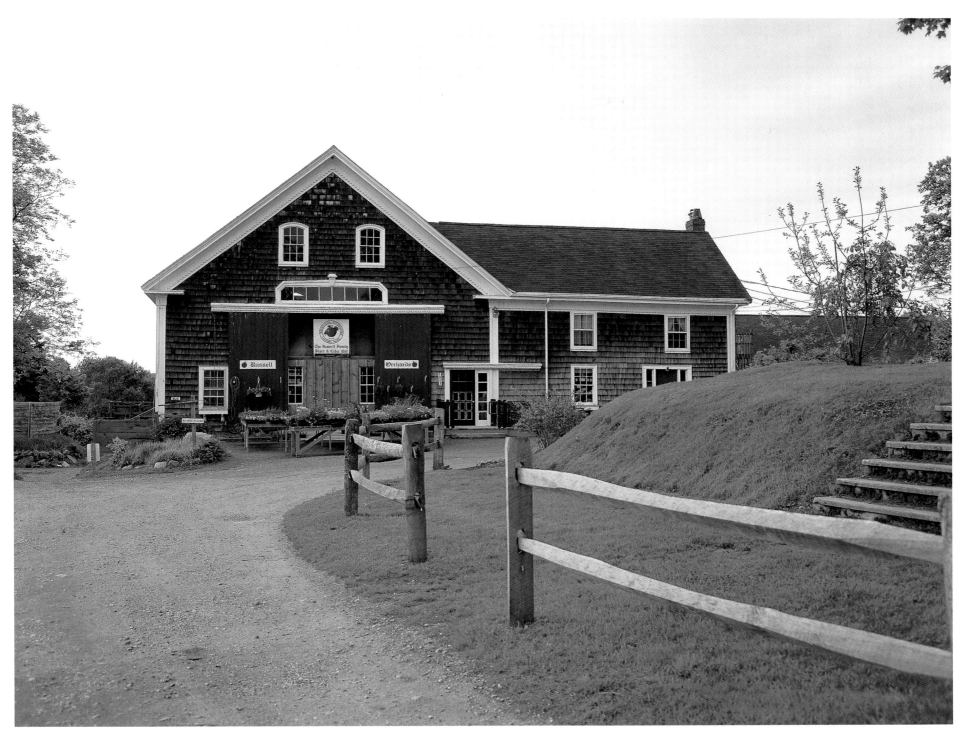

Russell Farm and Winery. *I am drawn to Marini Farm in the spring and Russell Farm in the autumn—*
to reassure myself that they have not gone away, like so many other family farms in New England.

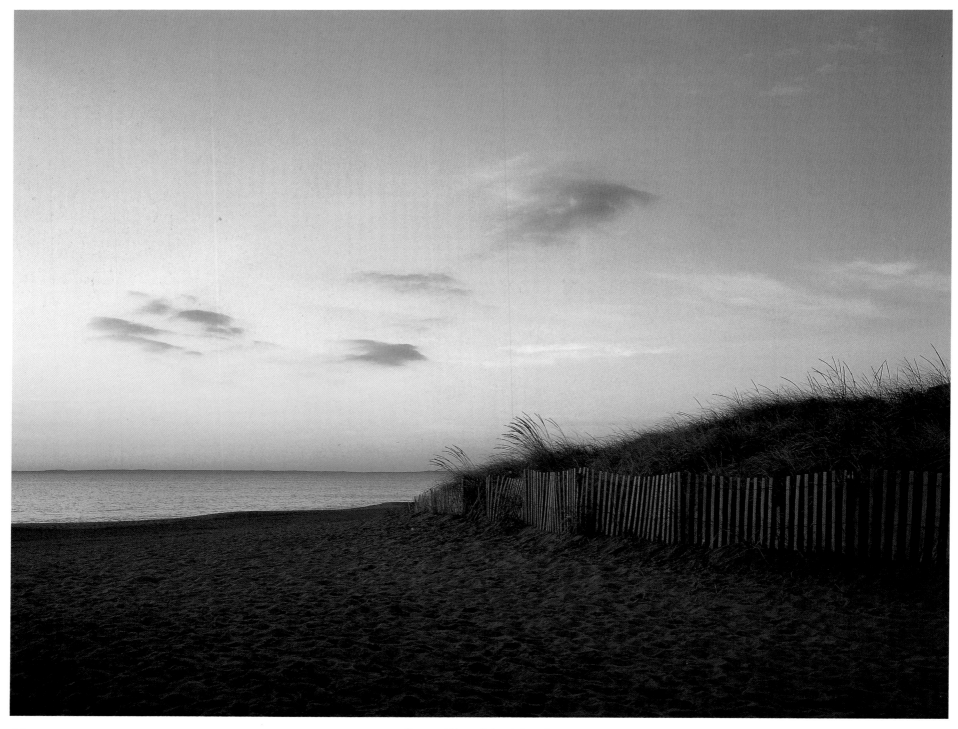

Dawn, Plum Island Beach

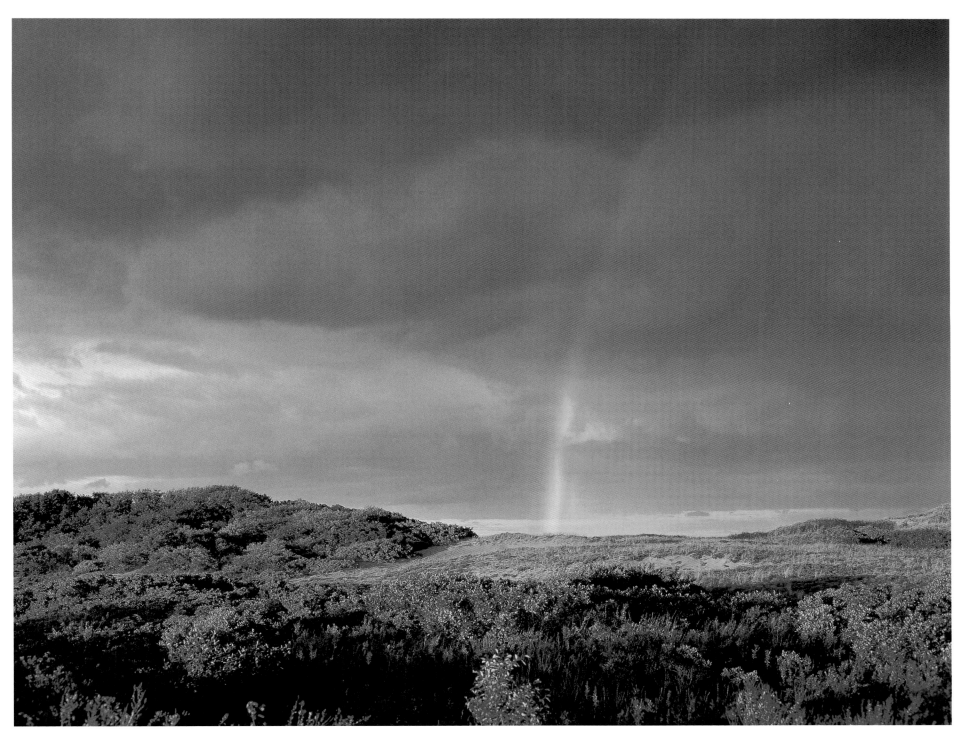

Rainbow over Plum Island. *They come and they go. I'm always looking forward to the next rainbow.*

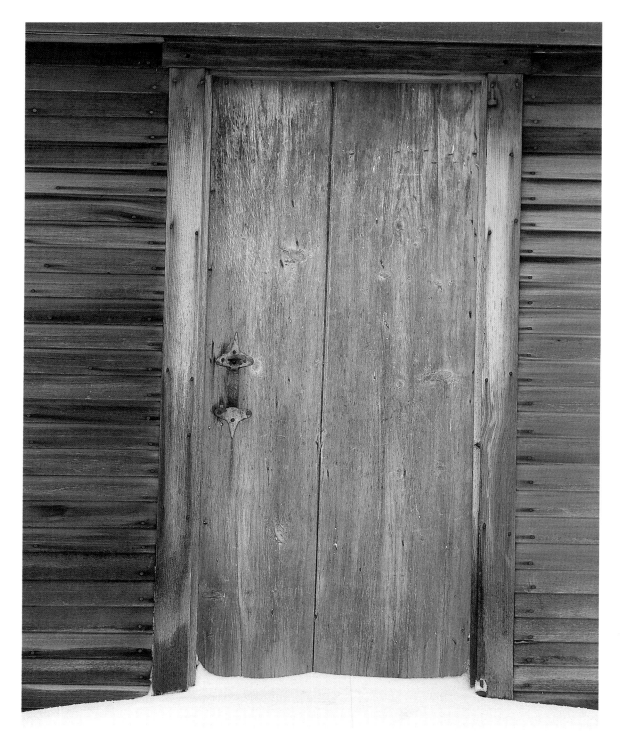

Weathered door, Turkey Shore Road.

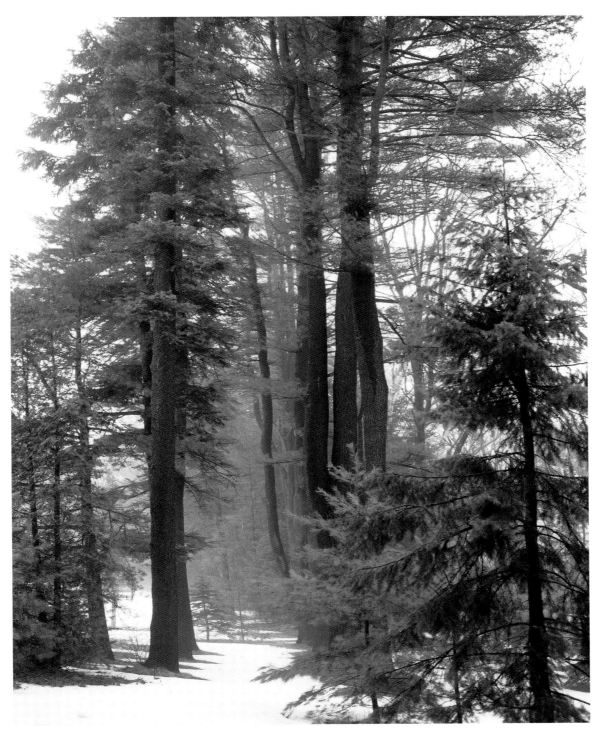

Ipswich Pines. *I never tire of these stately trees on the drive through Waldingfield Road.*

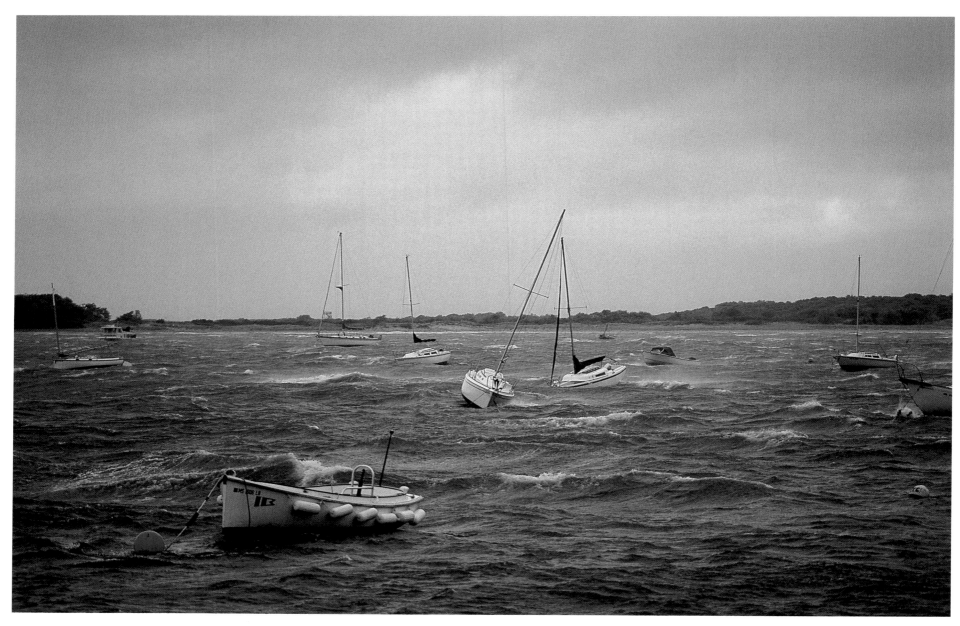

Storm Warnings, Plum Island Sound. *The tail end of Hurricane Gloria at Ipswich Bay Yacht Club, 1985.*

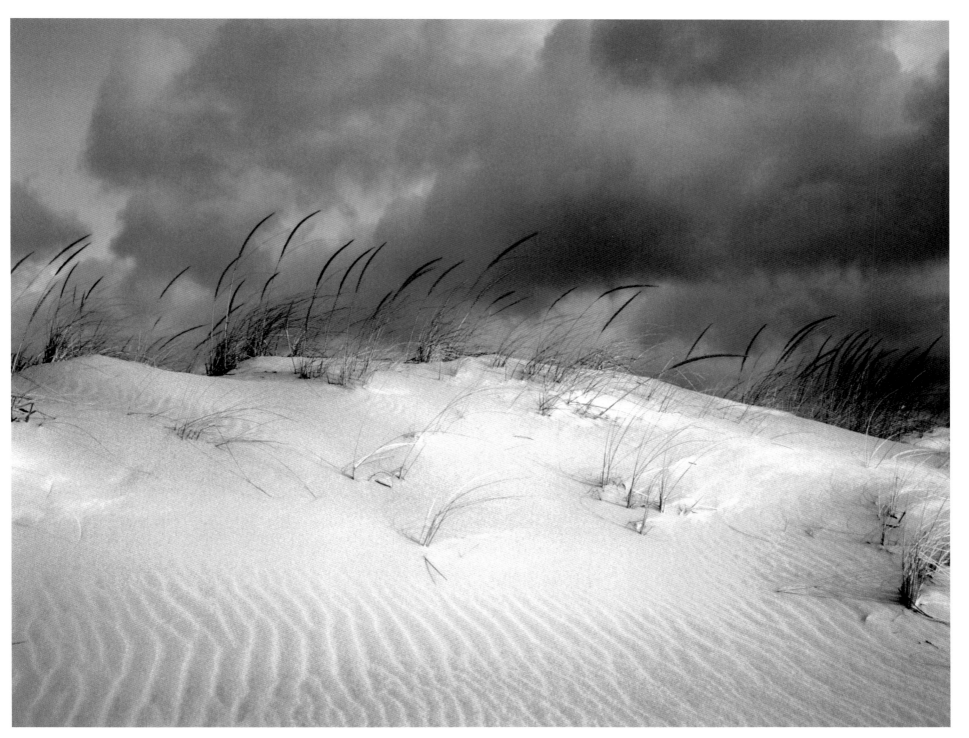

After the Storm, Crane Beach

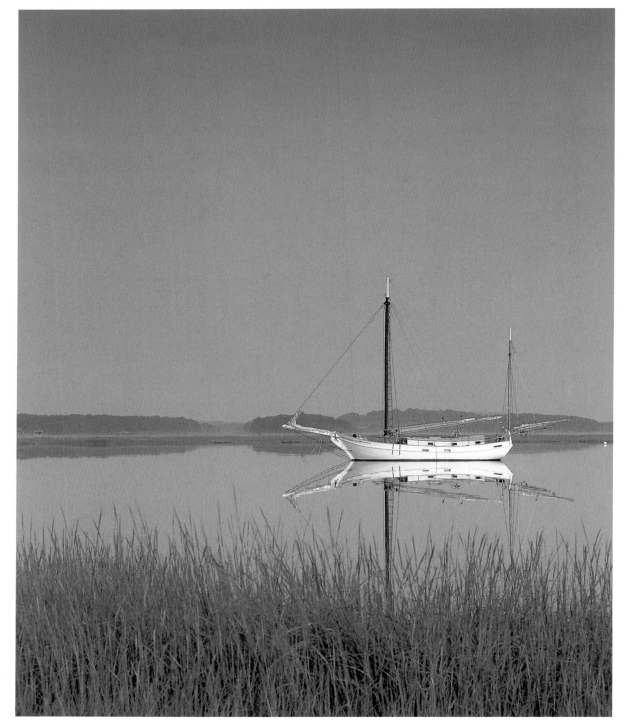

Rachel, Eagle Hill River.
A replica of Spray, *the vessel of Capt. Joshua Slocum, who made the first solo navigation of the world.*

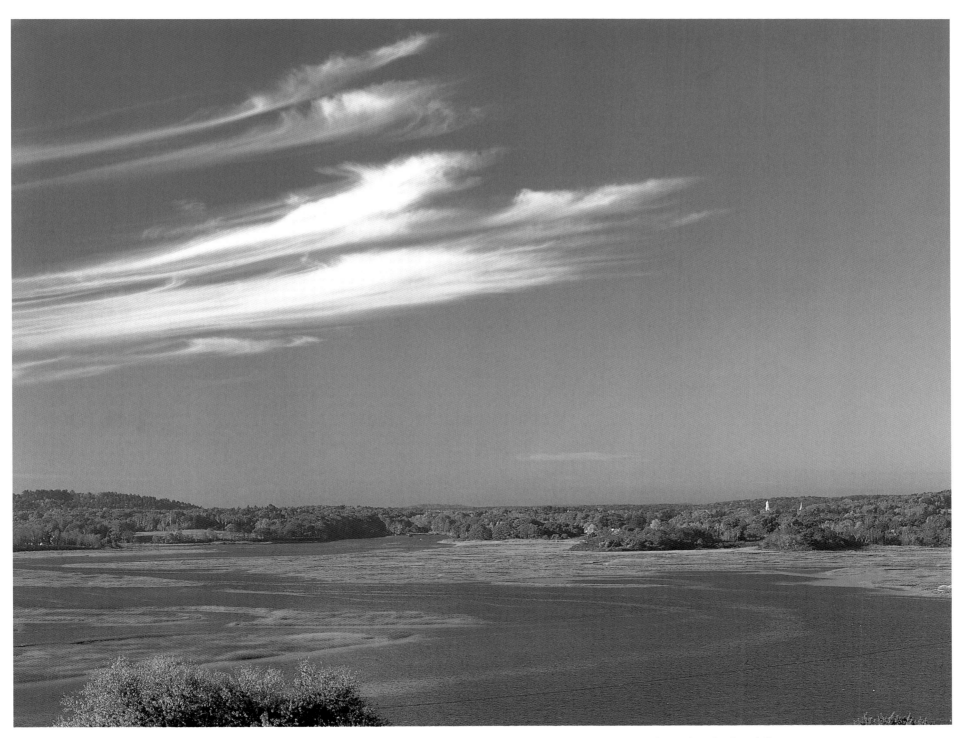

Ipswich River Sweep. *At high tide, the river is wide and beautiful, surrounded by a great salt marsh and rolling hills.*
To boaters, it is the gateway to a number of quiet creeks on the sound, bay, and sea.

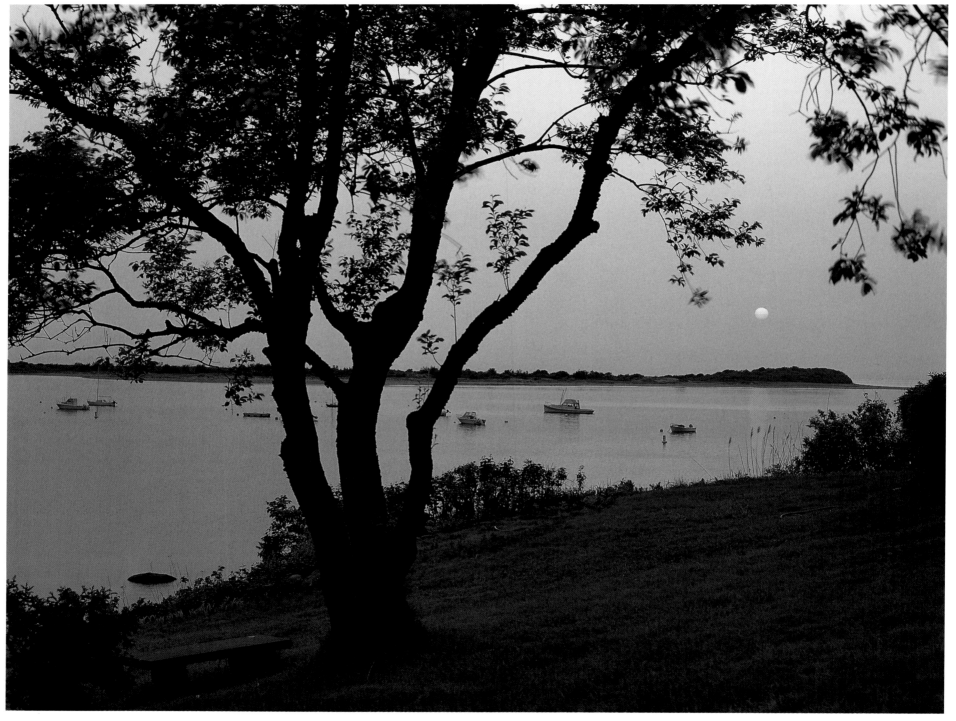

From Little Neck

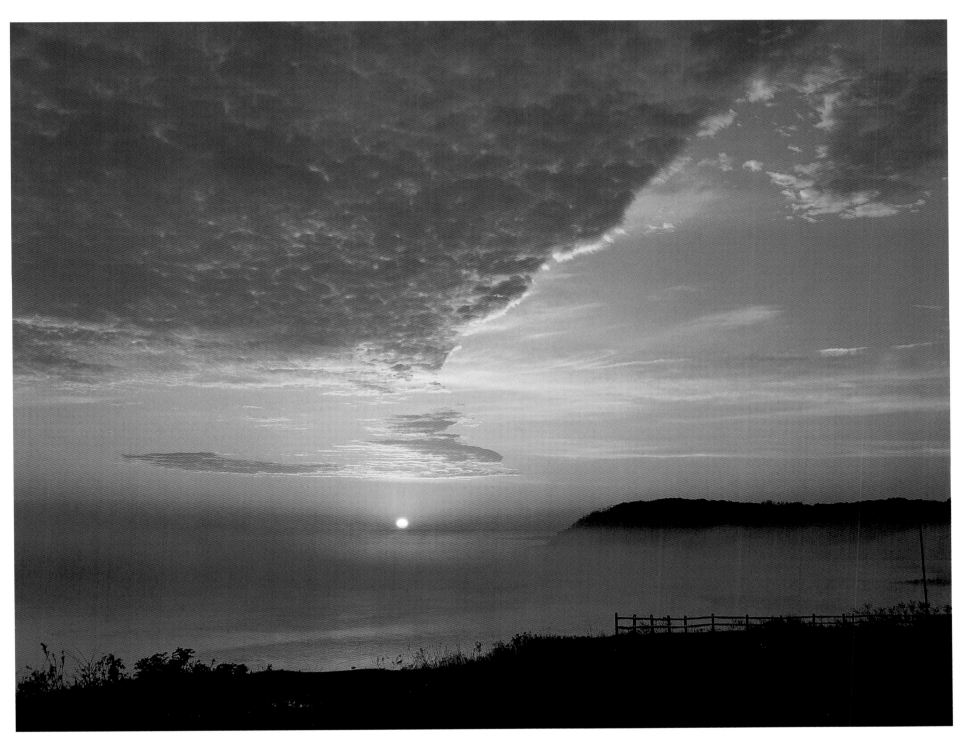

Ipswich Bay from Little Neck. *Little Neckers are warm and friendly people.*
No Puritan hangover here, except for the term "feoffee," the term for a trustee of the original Little Neck land grant.

89

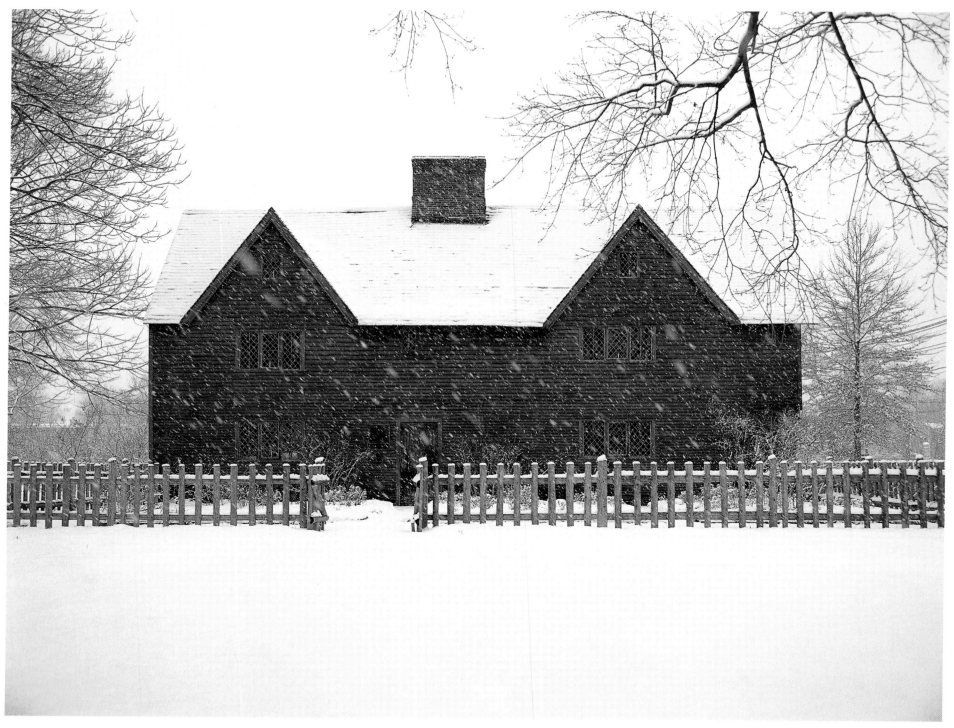

Whipple House, 1655, Winter

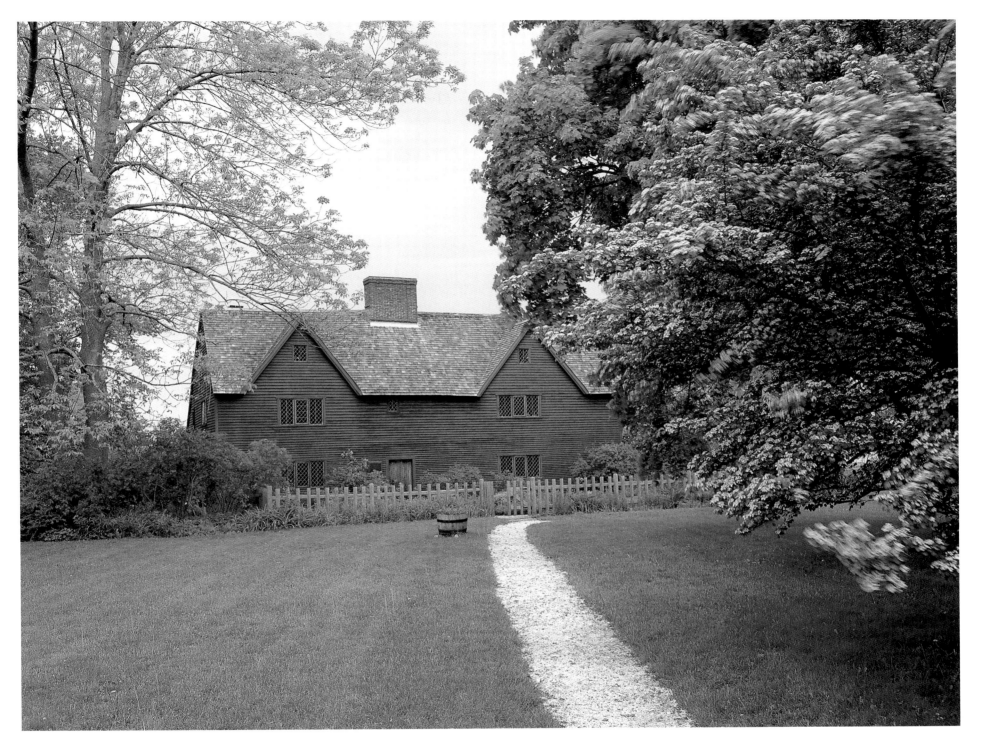

Whipple House, 1655, Spring

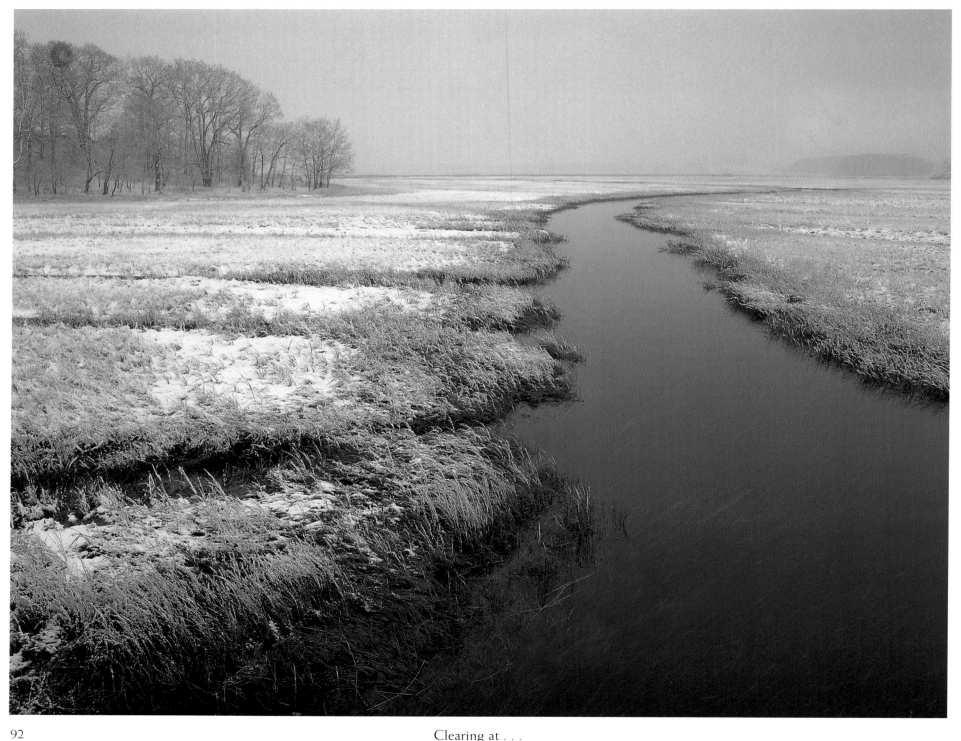

Clearing at . . .

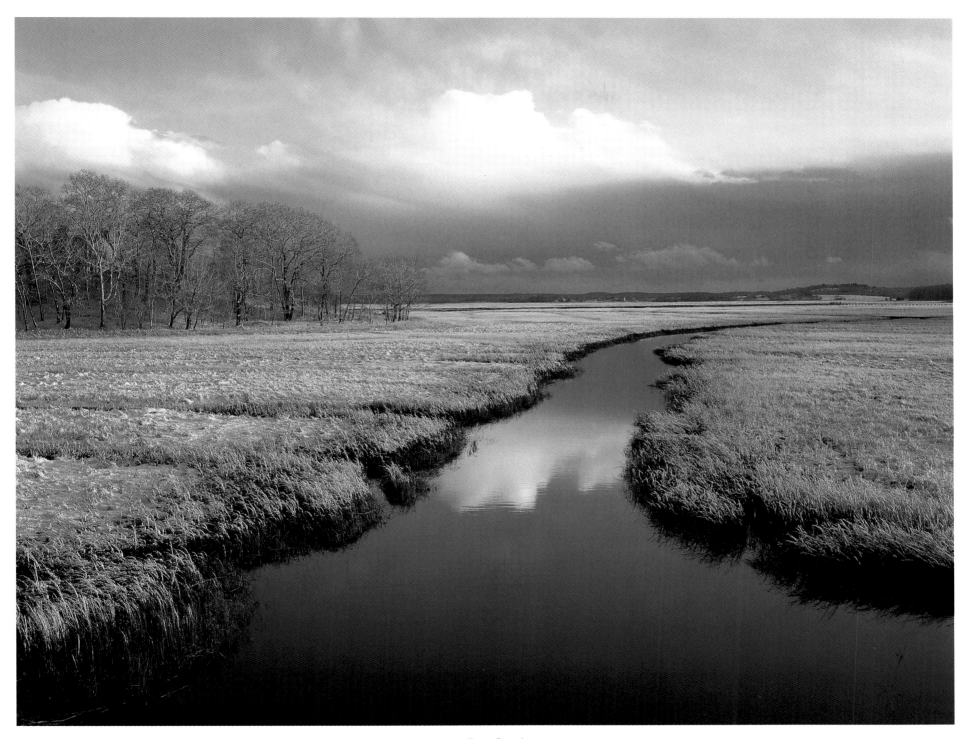

. . . Fox Creek

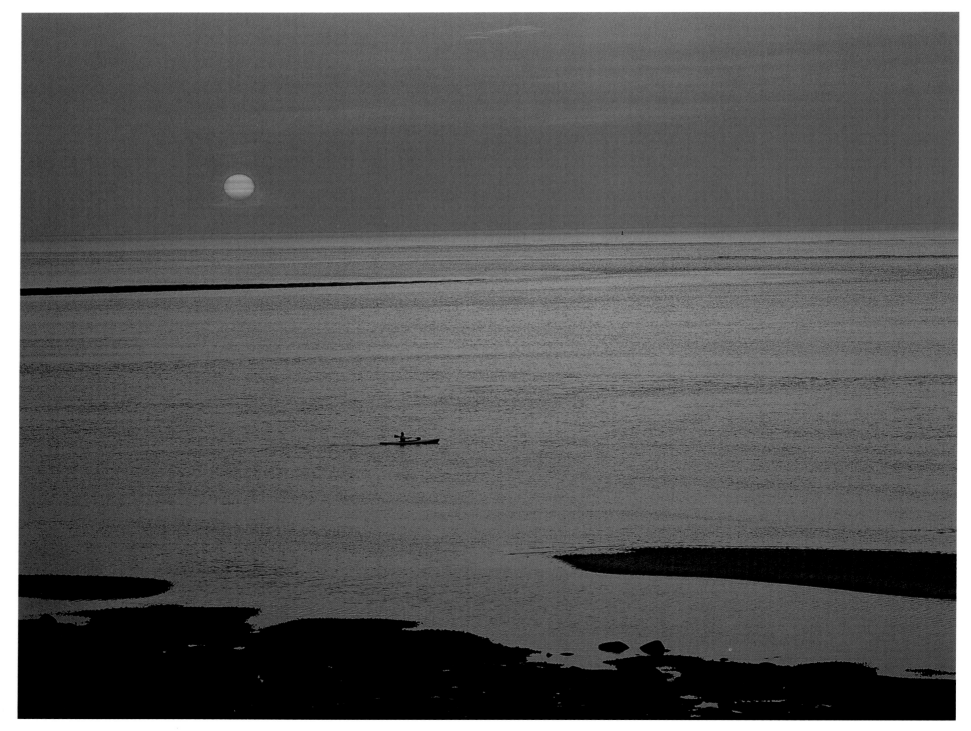

Ocean Kayaking

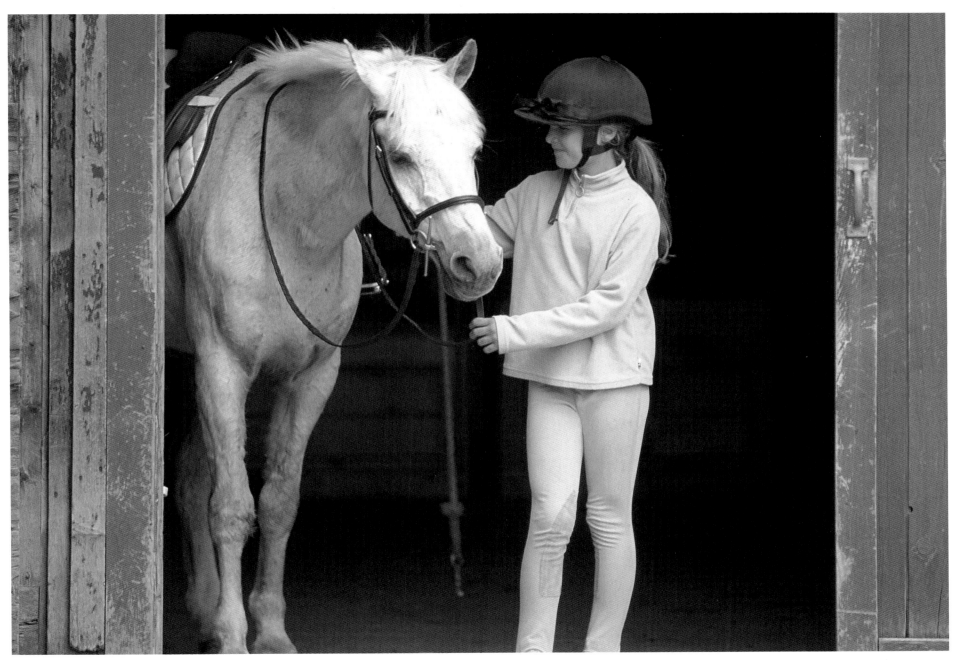

Katie, Ascot Riding Center

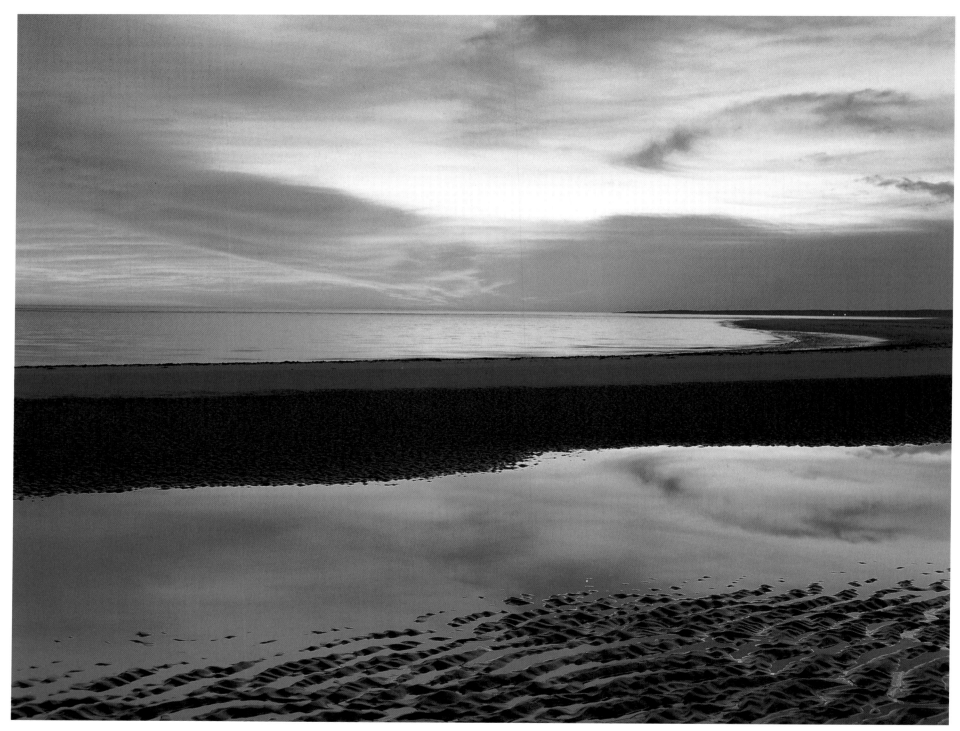

Crane Beach to Halibut Point. *With Plum Island Head, these two landmarks define the boundaries of Ipswich Bay.*

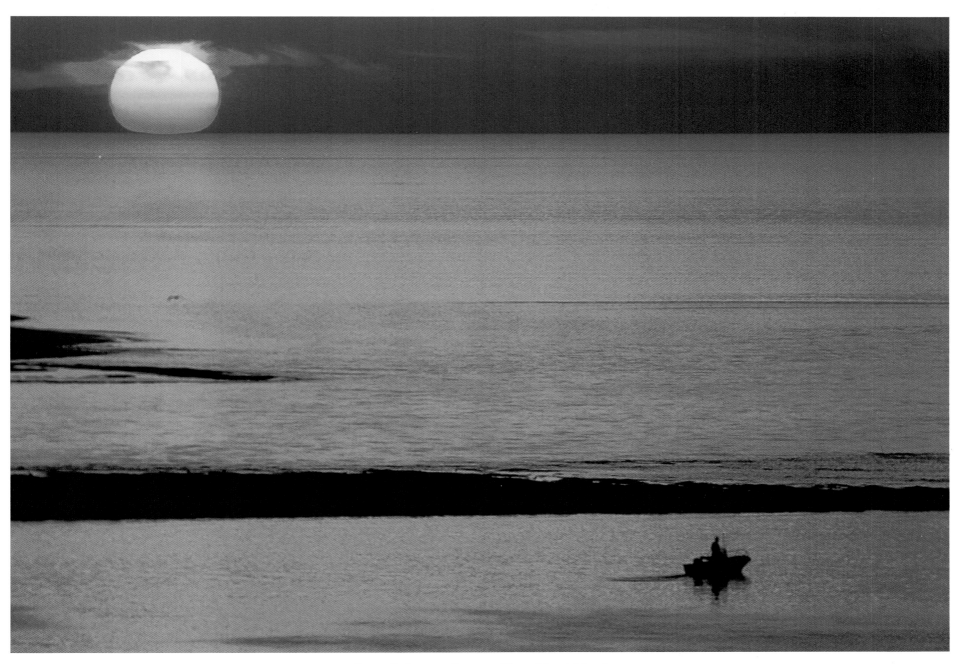

Sport Fishing at Sunrise, Plum Island Head

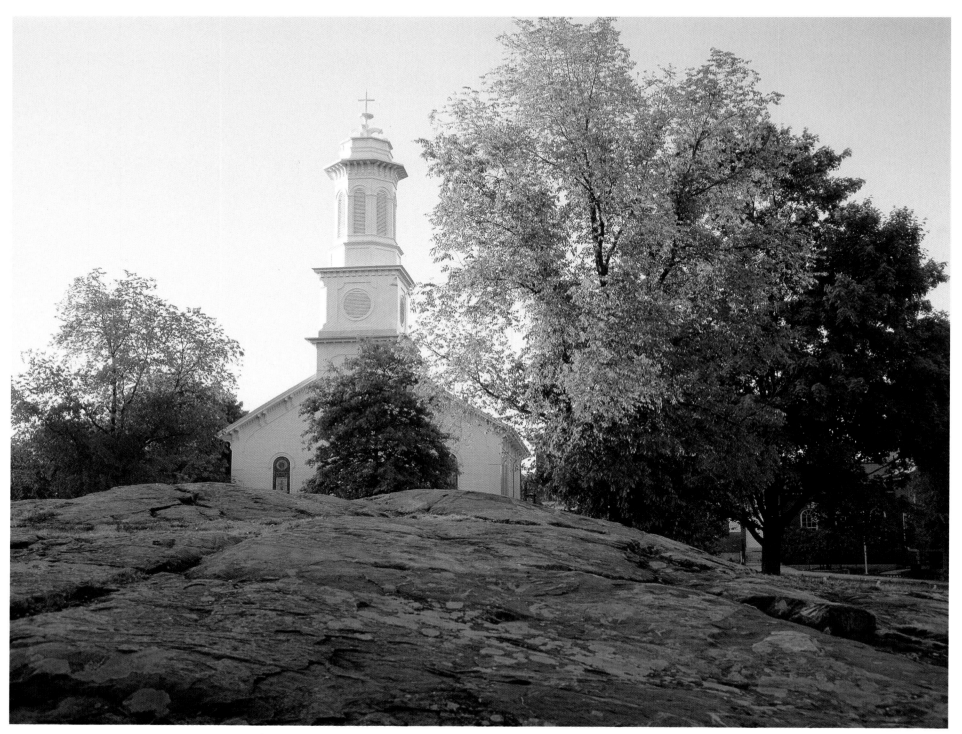

Town Hill. *The Methodist Church, established in 1859, is the oldest Ipswich church in continuous service.*

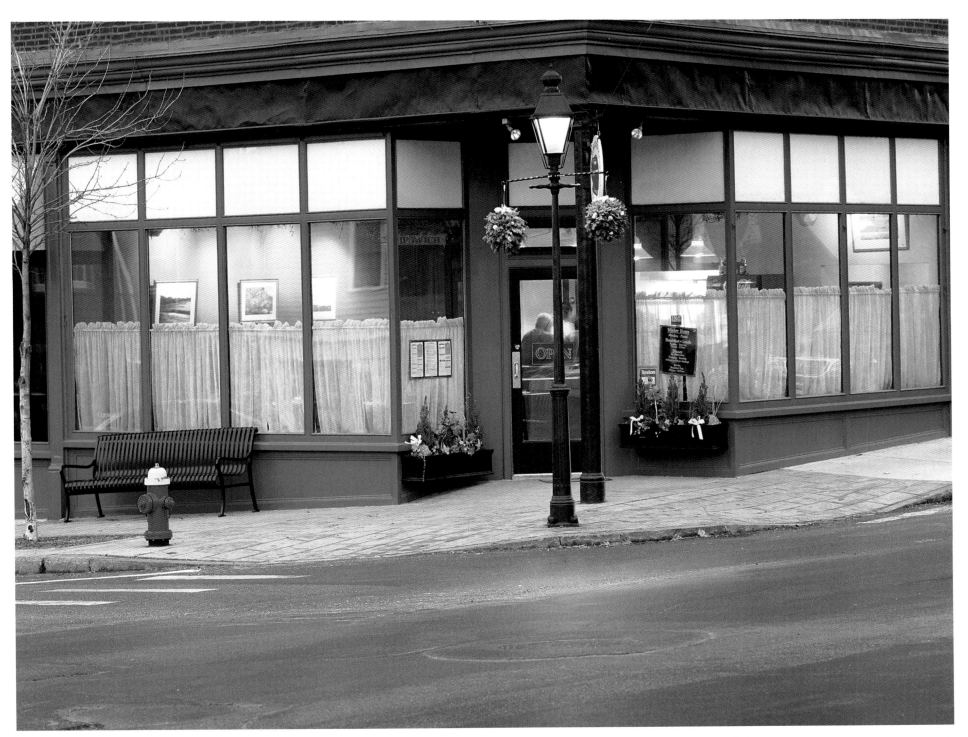

Stone Soup Café. *There are many good eateries in Ipswich. Even if you dislike waiting in line, this one's worth the wait.*

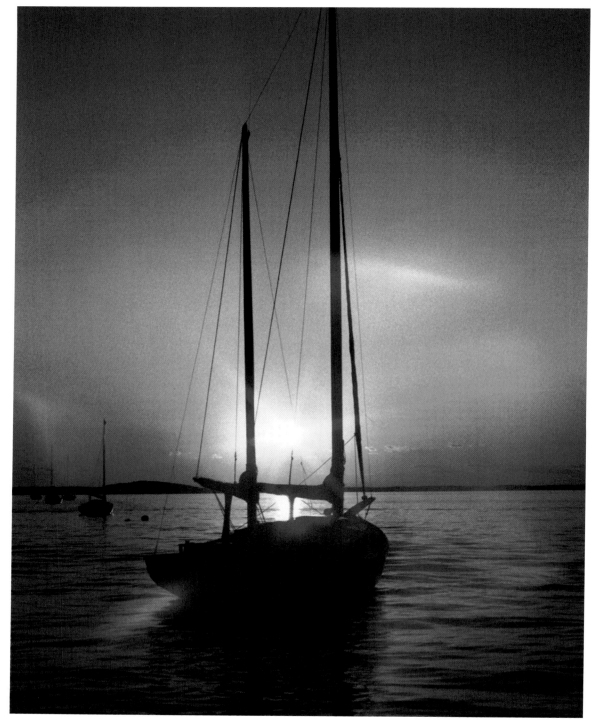

Sundowner, Plum Island Sound. *A salty cat ketch at sunset.*

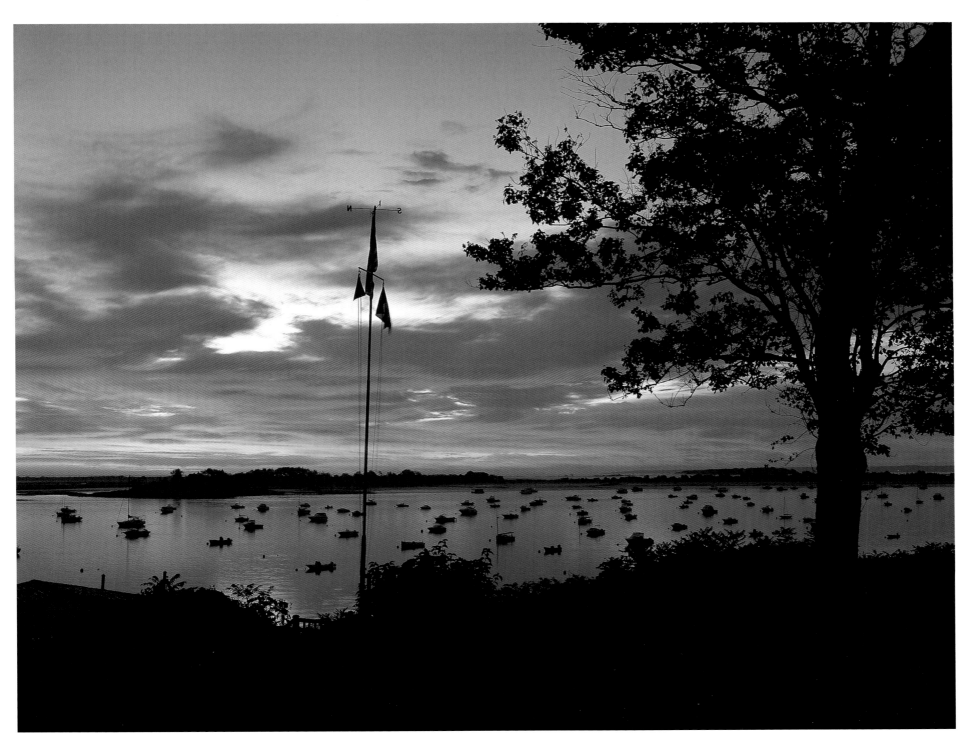

From Ipswich Bay Yacht Club

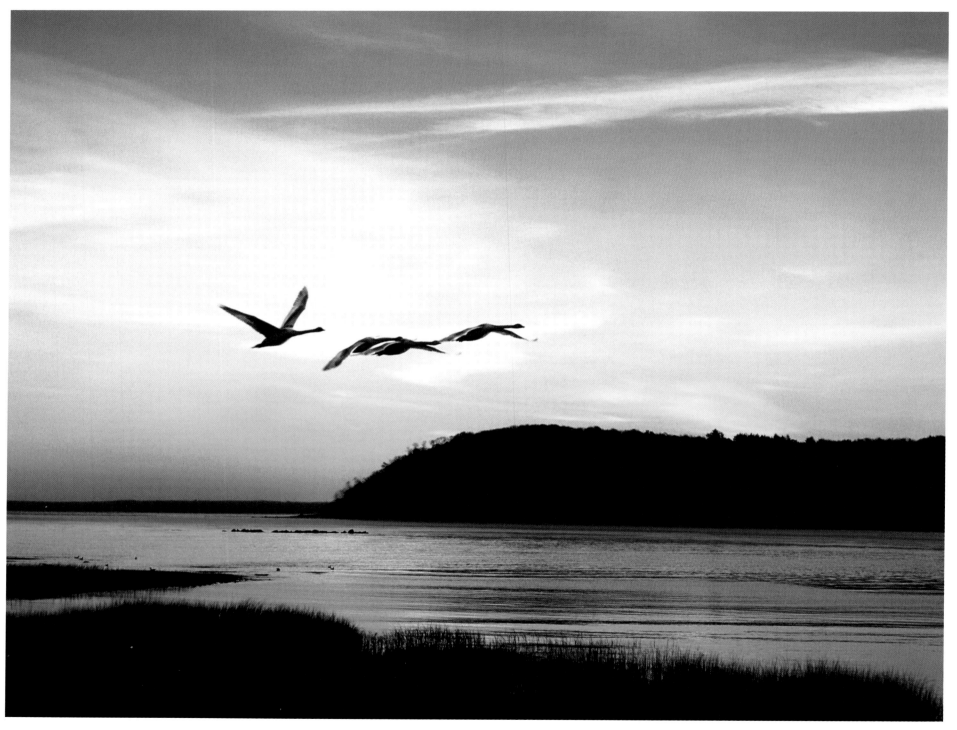

Swan Flight, Steep Hill. *For many years, a good image of swans in flight evaded me.*
Only after watching their habits at Clark Pond did I narrow chance. Finally, I set up my camera a mile away and waited with confidence.

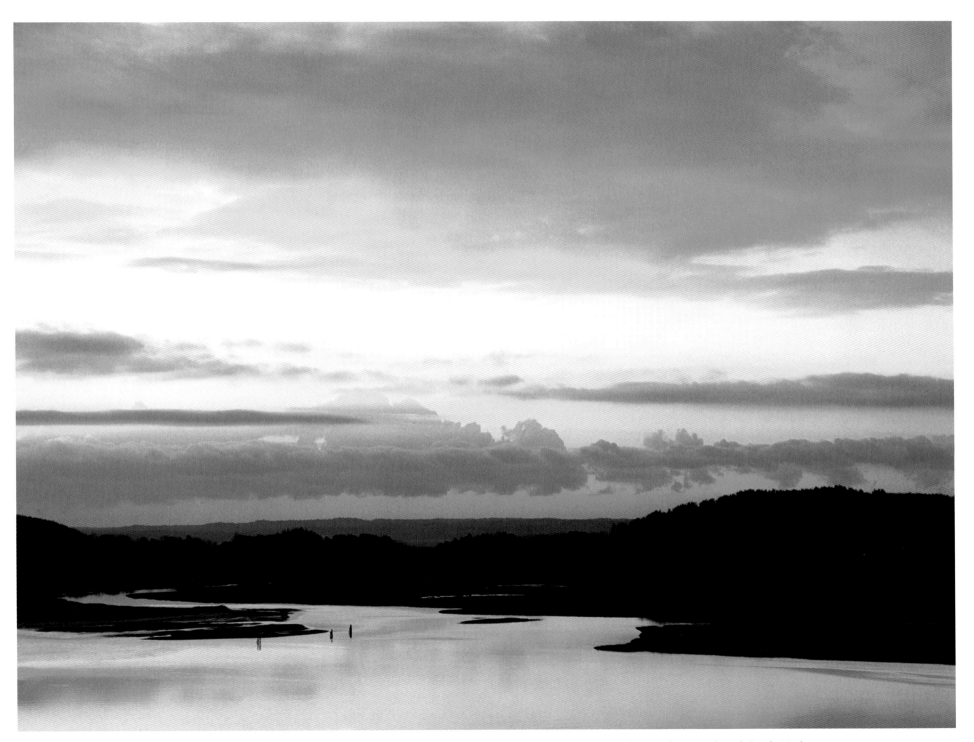

Ipswich River to Fox Creek. *The most popular creek for boaters, Fox Creek has a long history. It joins the Ipswich and Castle Neck rivers.*

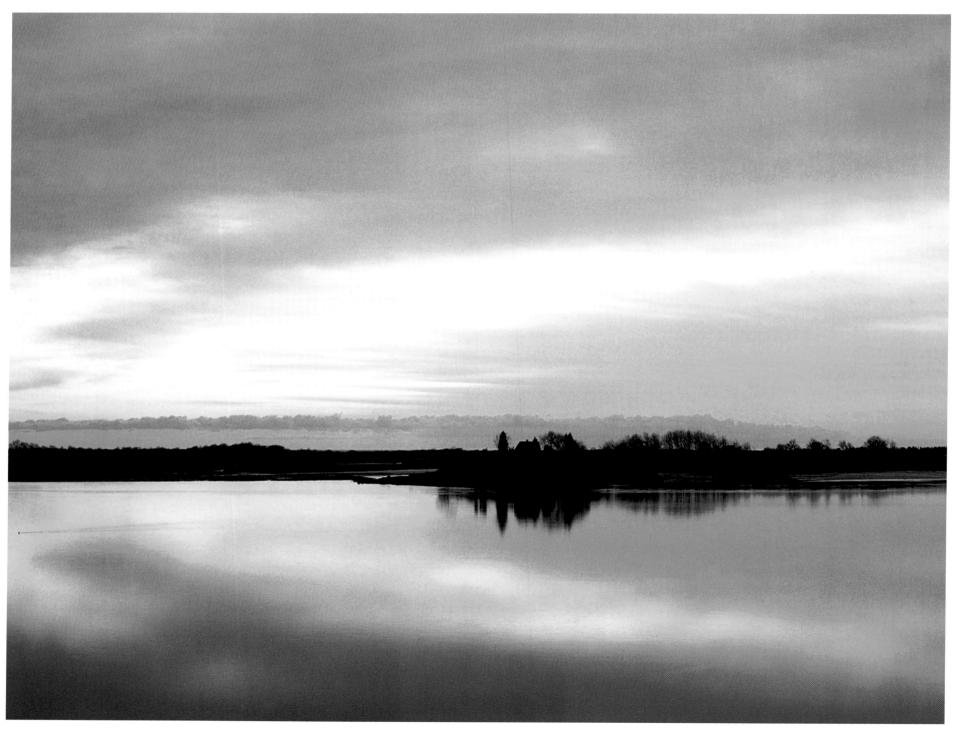

Dawn, Plum Island Sound

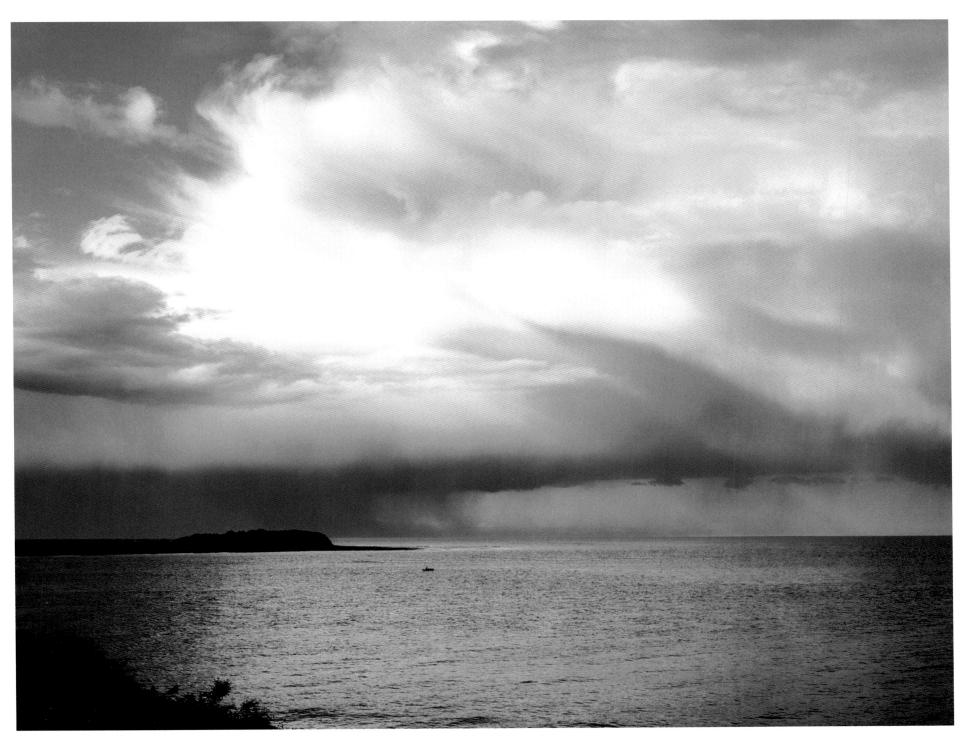

Thunderstorm, Ipswich Bay. *If you look carefully, there is a lone figure in a small boat. If you look closer still, he has one eye to seaward, one eye on shore.*

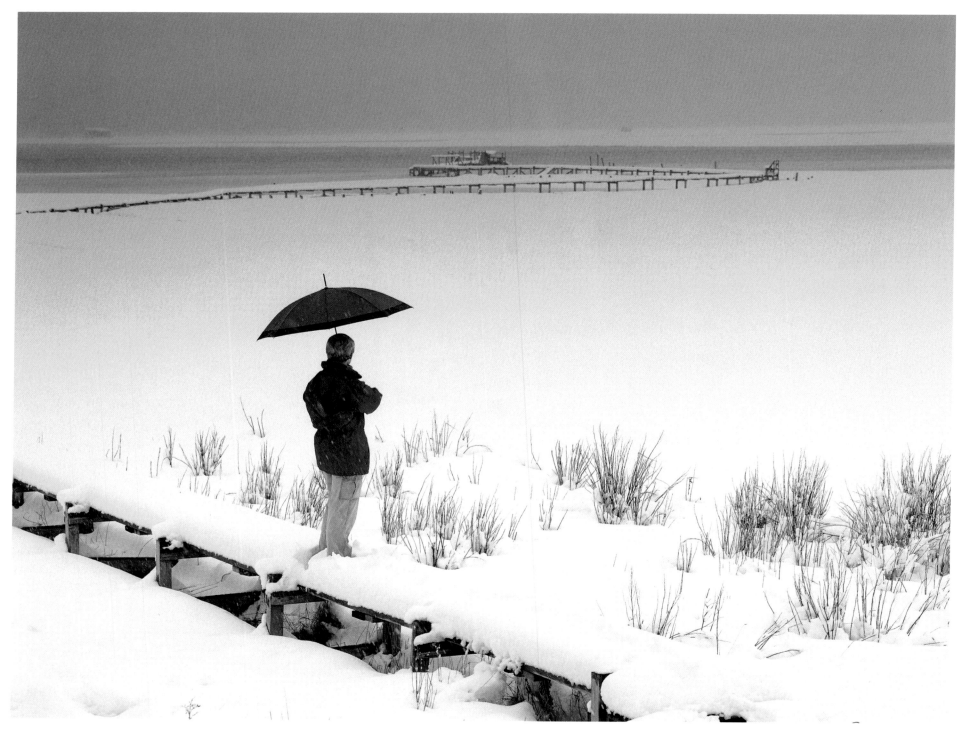

Nancy, Castle Neck River. *Nancy makes friends easily. It's a natural gift.*
When I need the cooperation of private citizens in special places, Nancy is one of the people I call on.

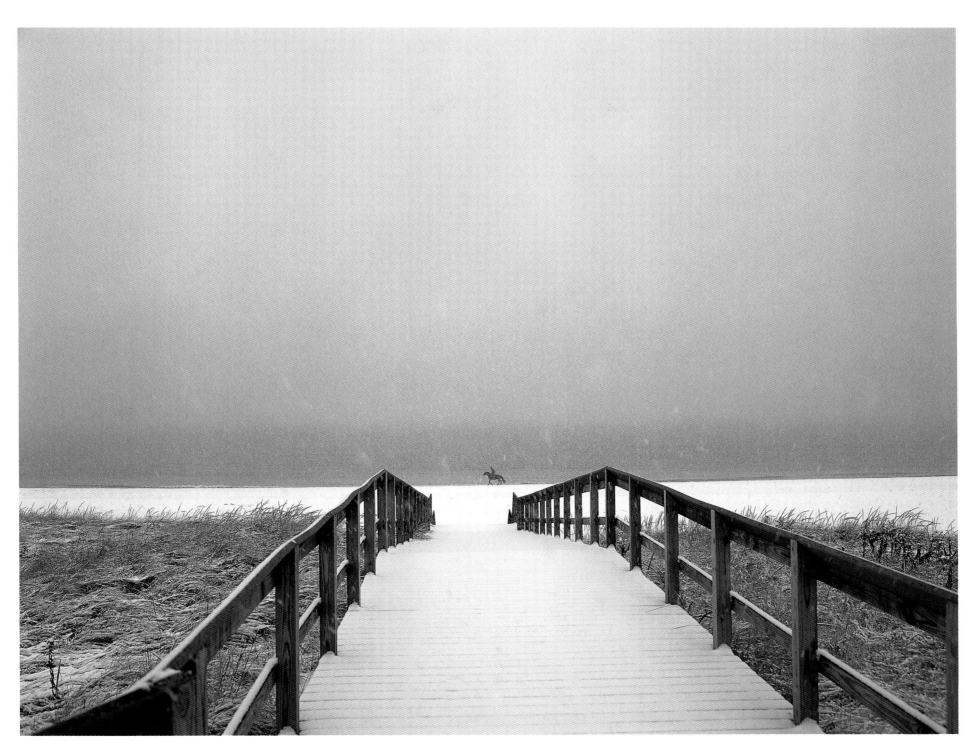

Lone Horseman, Crane Beach, Winter. *A warm horse with sure footing can make your day.*

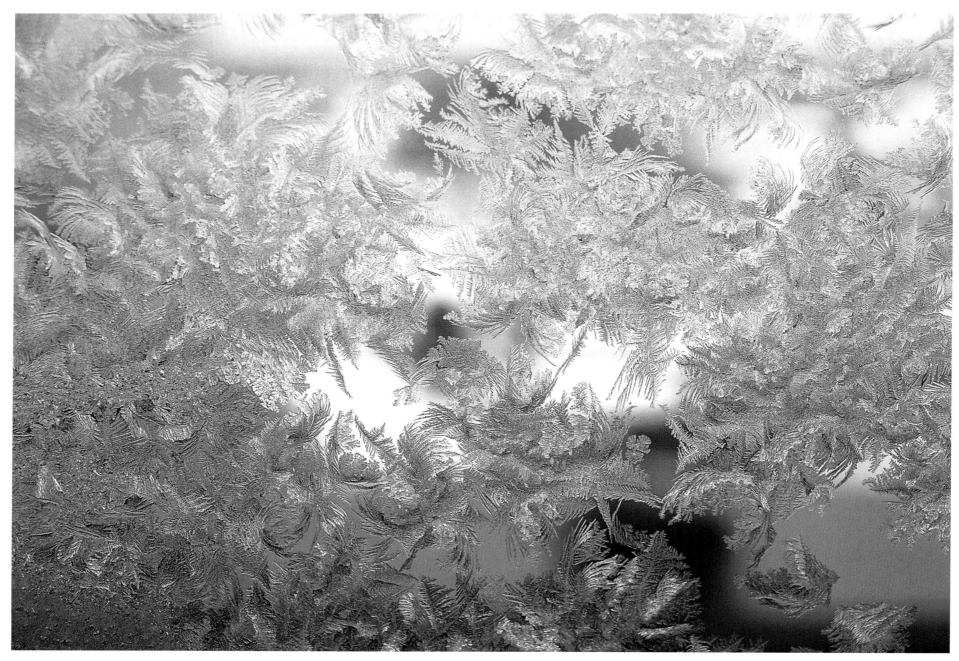

Frost on My Window

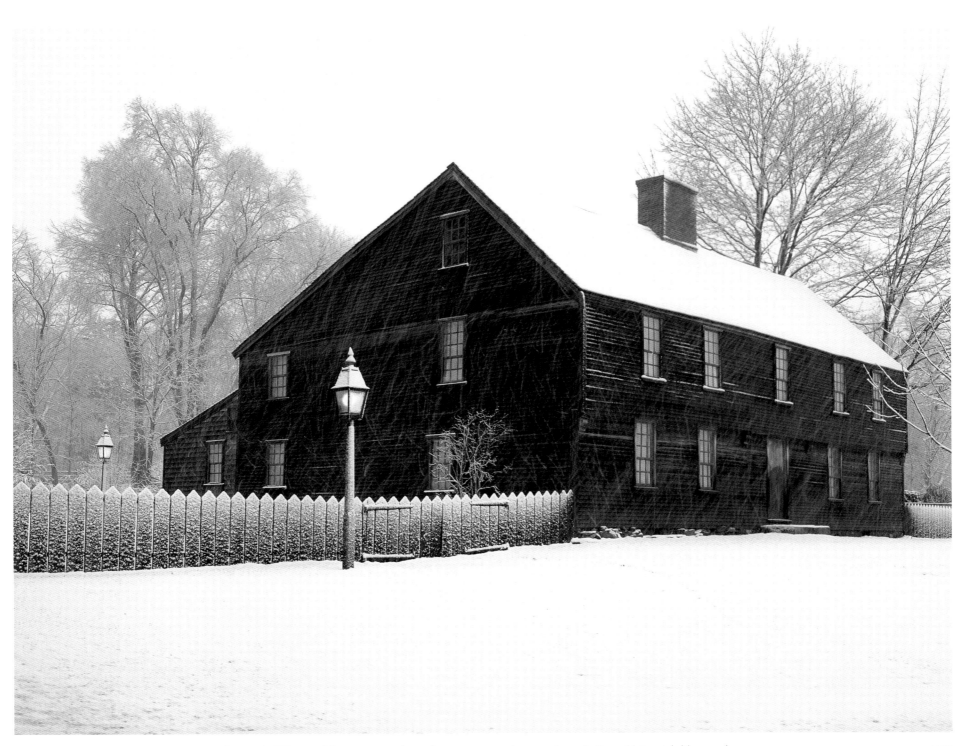

Ipswich Winter. *This intriguing house has no name or date, yet it symbolizes old Ipswich like no other.*

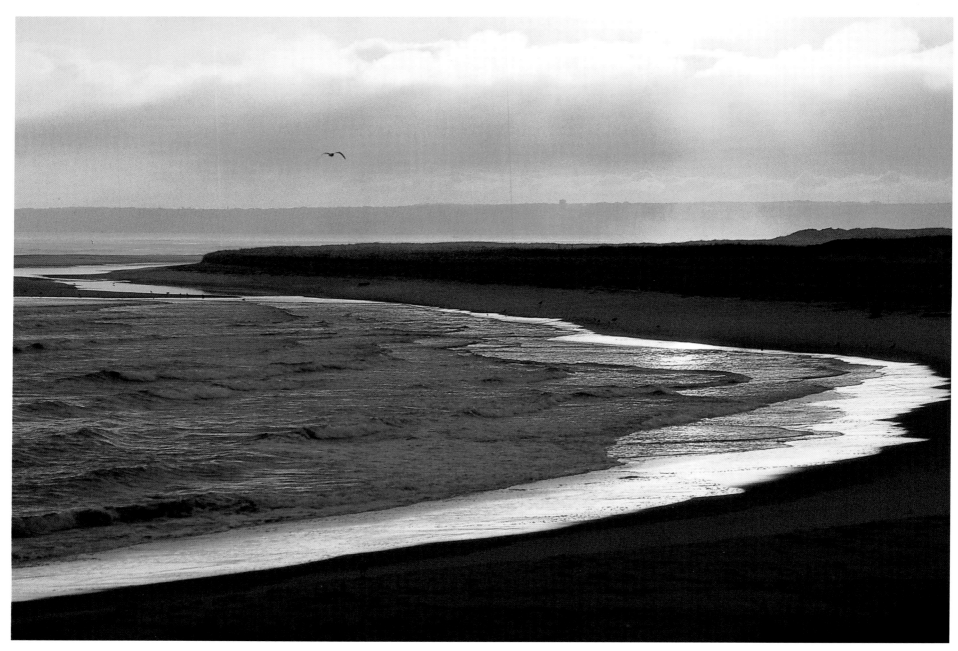

Sunrise, Castle Neck

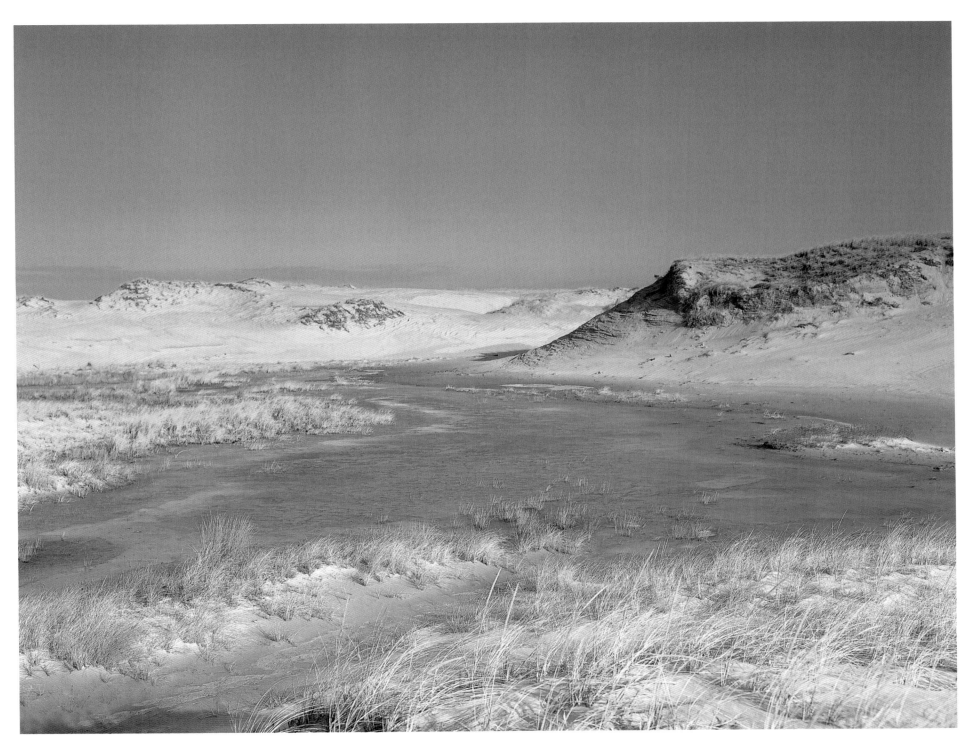

Castle Neck Sand Dunes. *This landscape is forever changing, in wind and tide.*

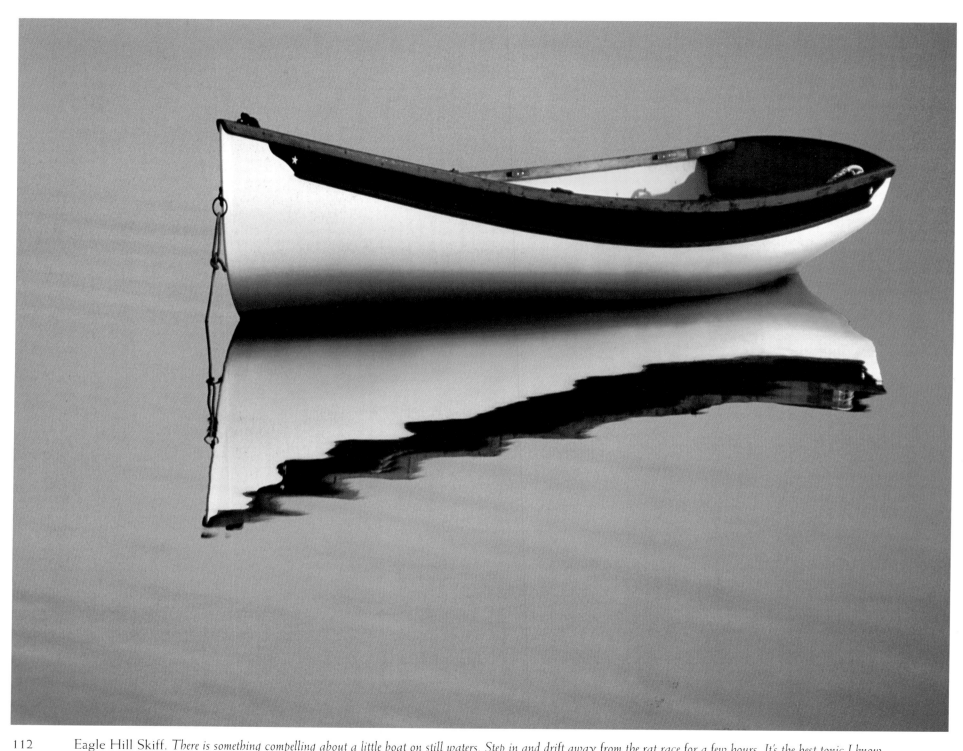

112 Eagle Hill Skiff. *There is something compelling about a little boat on still waters. Step in and drift away from the rat race for a few hours. It's the best tonic I know.*

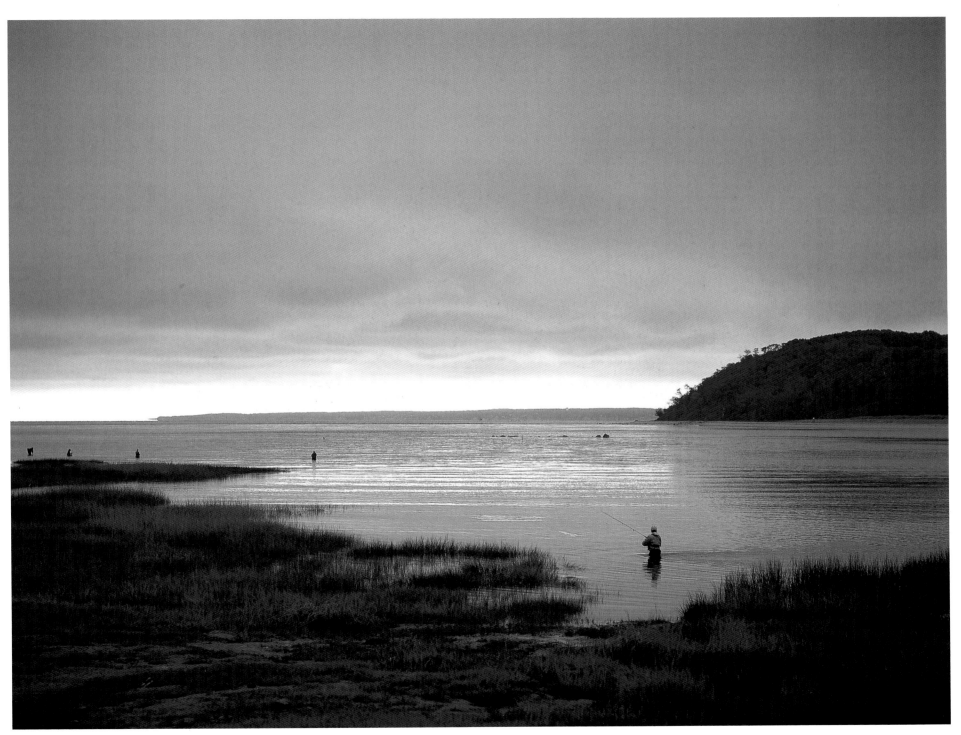

Fishing at the Mouth of Ipswich River. *In the early fall, long before sunrise, fly fishermen apply their skill, alone with themselves and nature.*

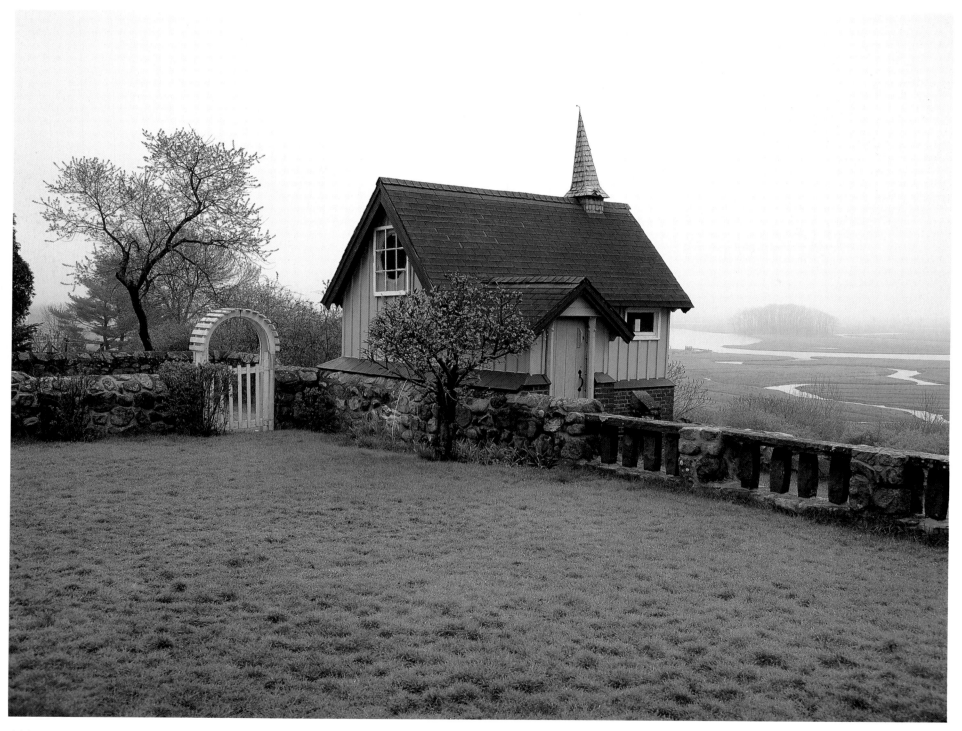

Cottage by the Salt Marsh

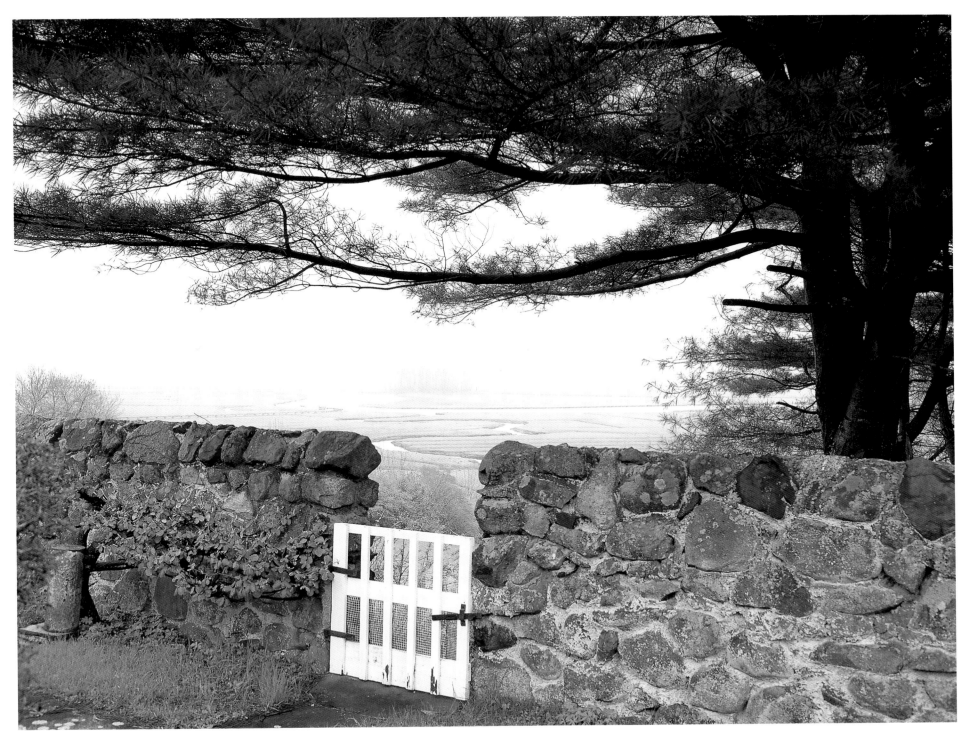

Sea Gate. *Many years ago, a man had a vision. He built his home from stones on the hill overlooking the marsh and sea. Back then, folks in town thought it was an odd place to build. Now, with envy, we admire what he did and where he did it.*

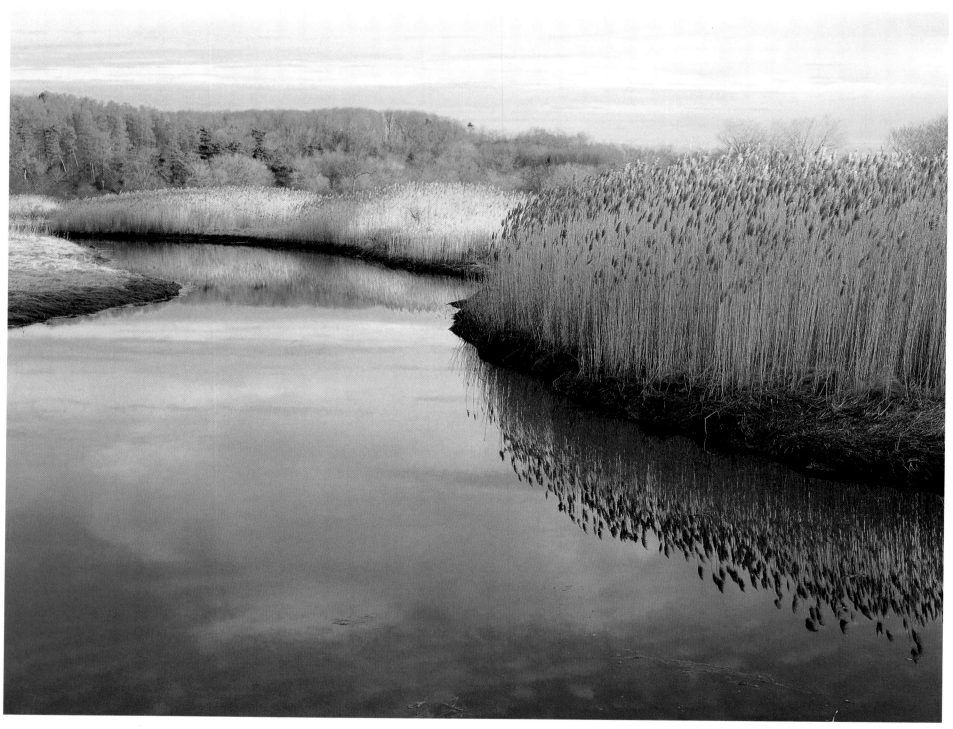

Castle Hill Marsh, Summer

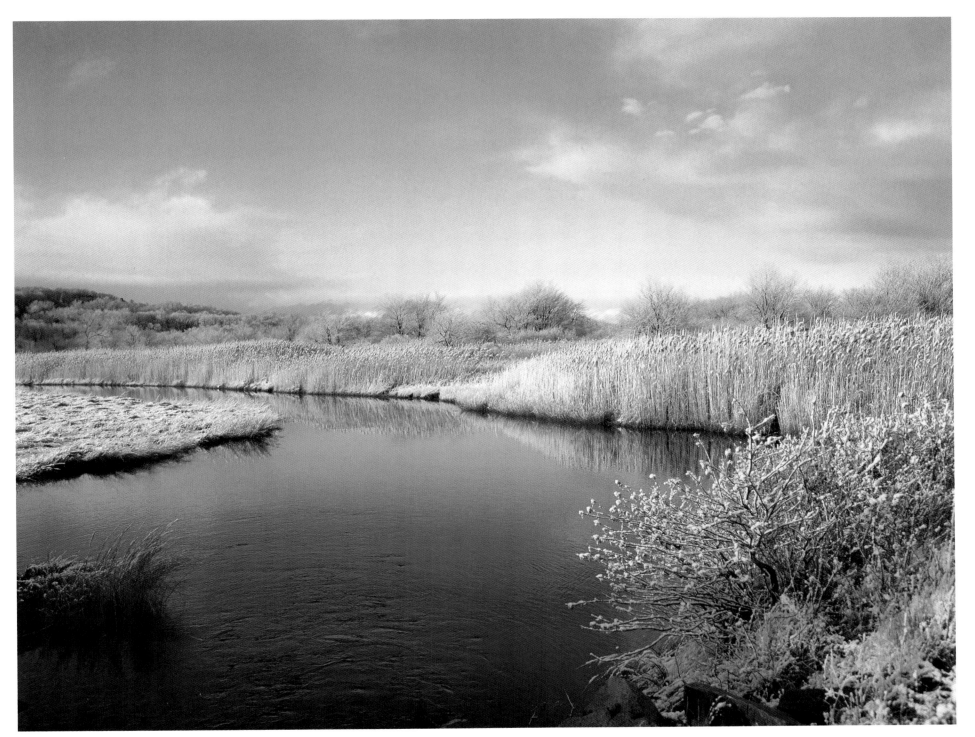

Castle Hill Marsh, Winter

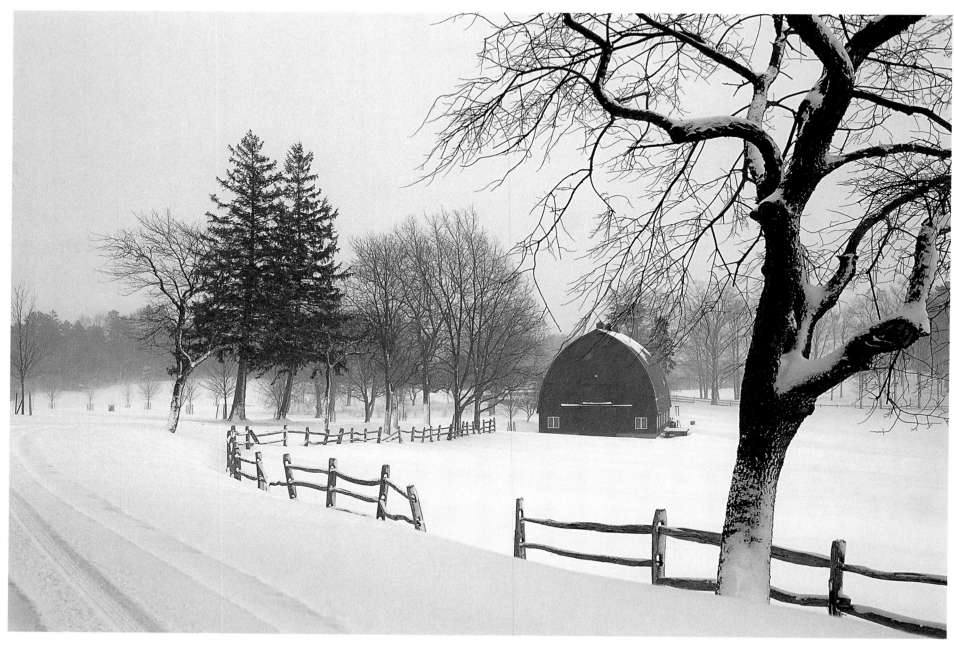

Along the Way

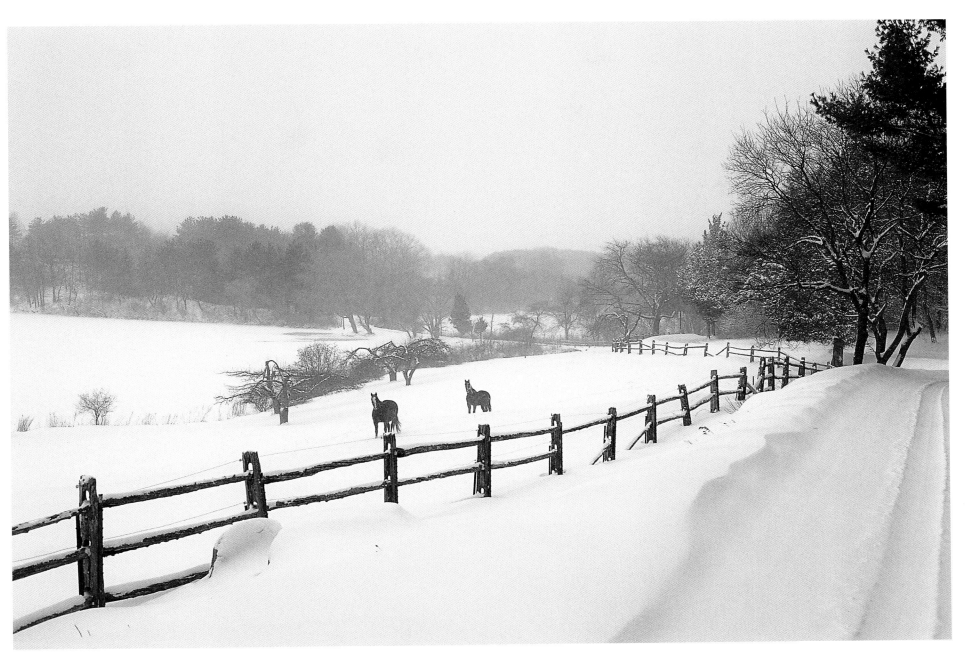

Fox Creek Road

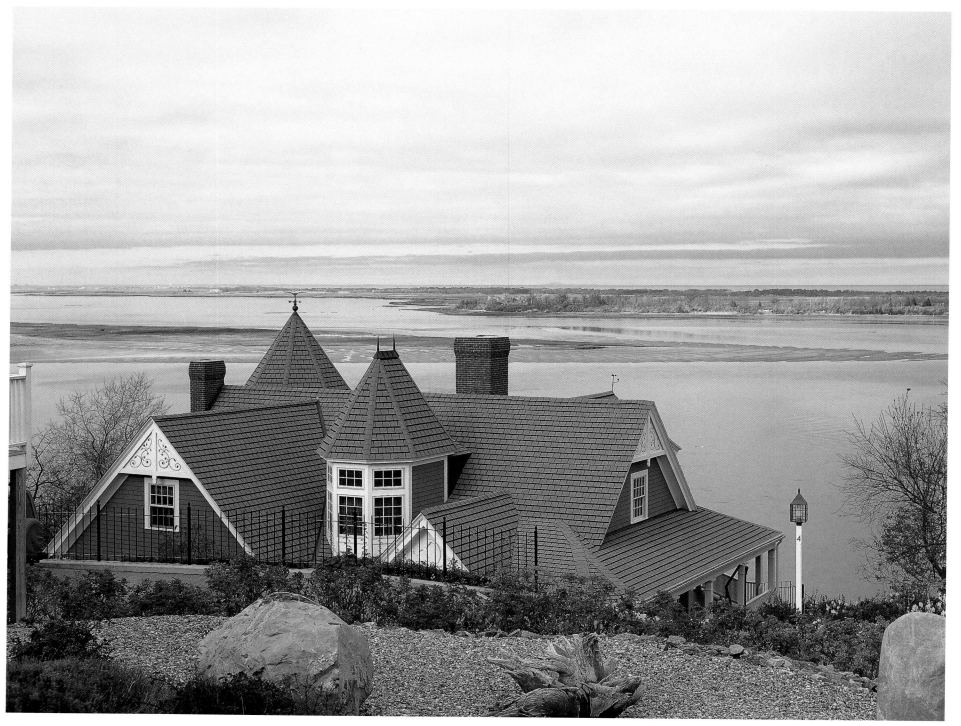

North Ridge to Middle Ground

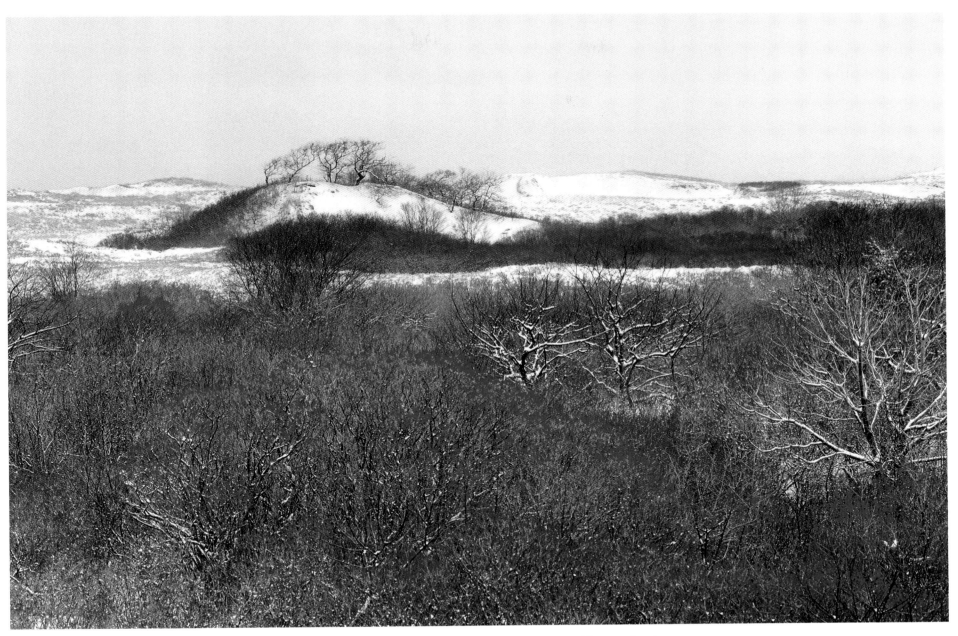

Plum Island Winter. *This is the time and place to stop and listen to the silence.*

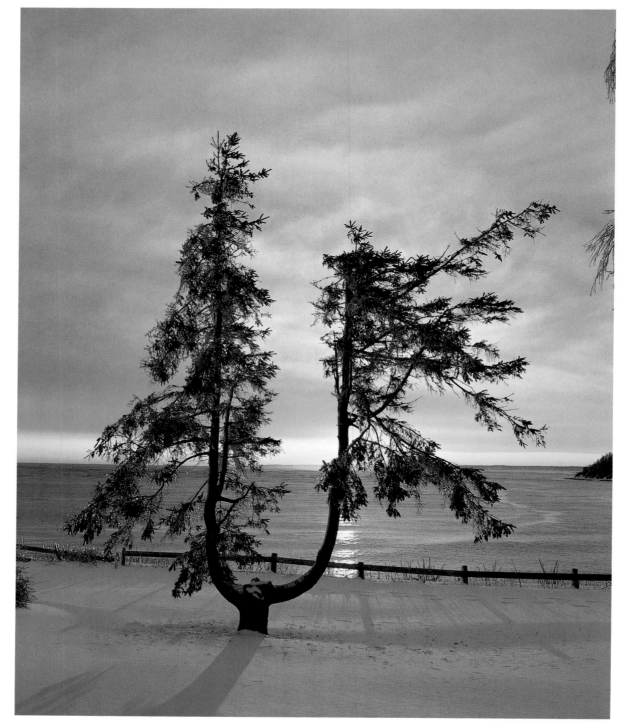

Tree at Little Neck

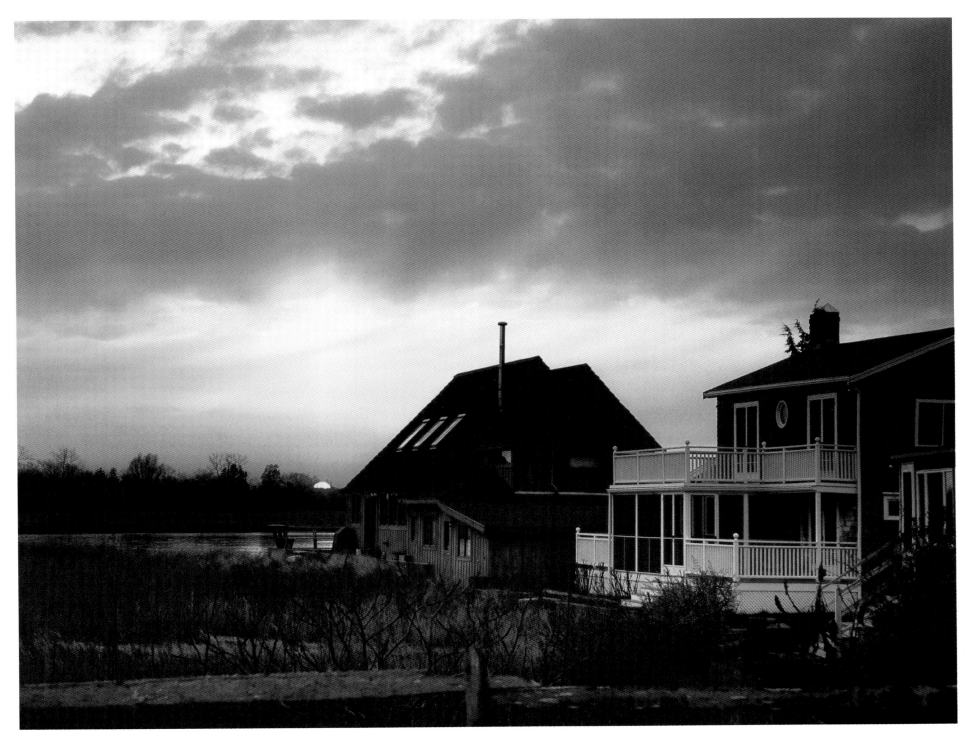

Little Neck, Sunset

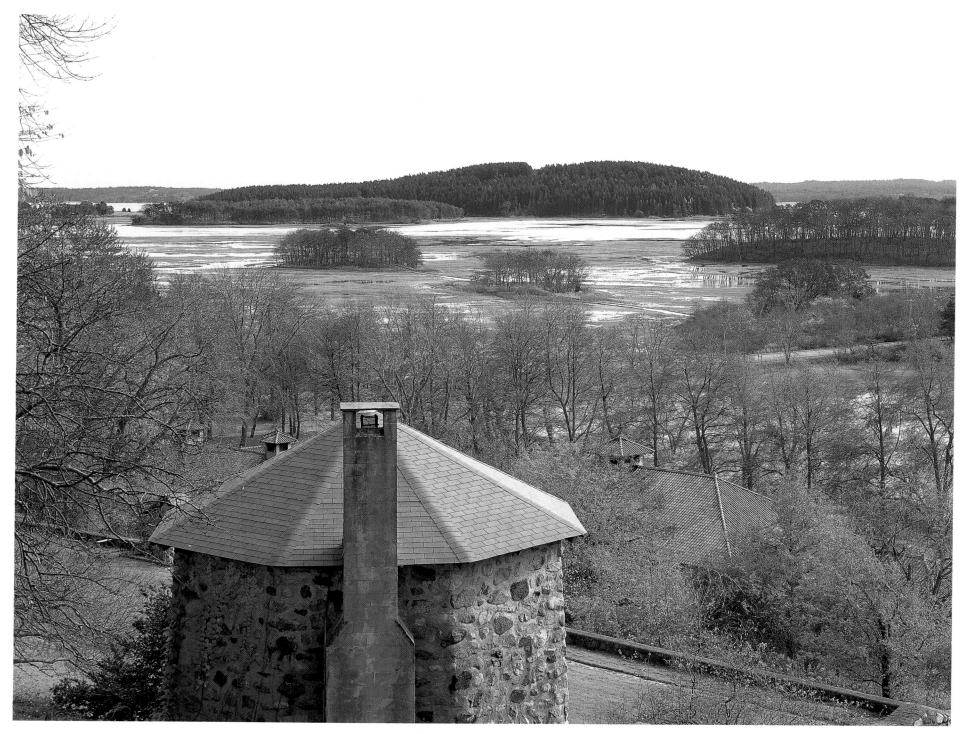

Castle Hill to Choate Island. *Choate Island, or Hog Island, has a distinct earmark all its own.*
That little dip in the crown of trees was a telltale welcome to many a homebound sailor.

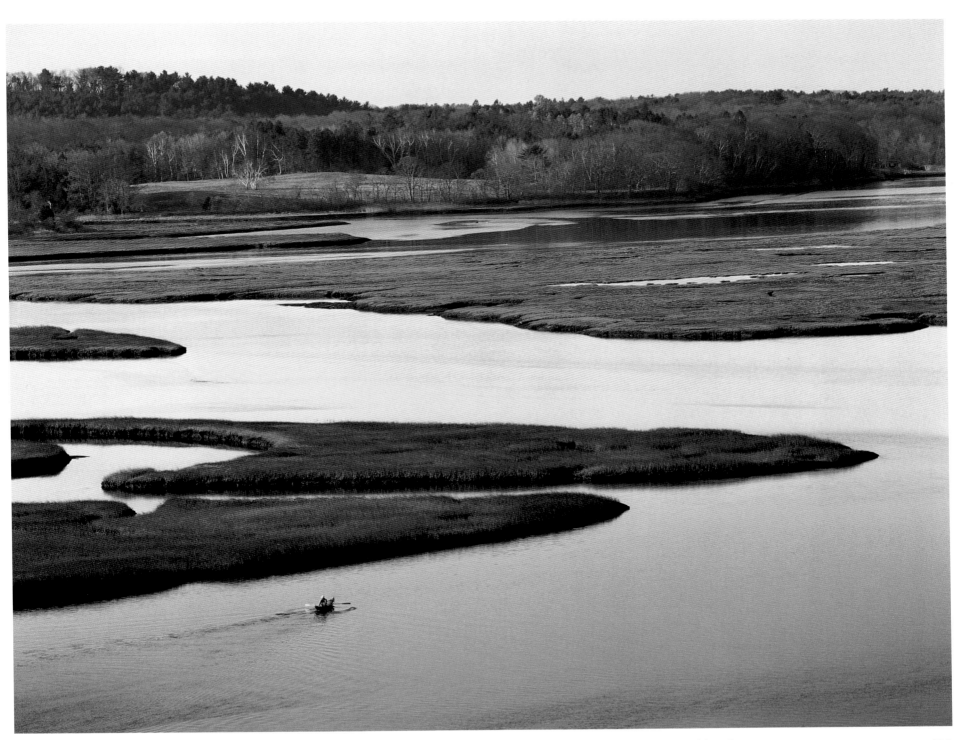

Rowing up the Ipswich. *Sam Messina built his dory and rowed upriver to find a quiet, restful creek.*

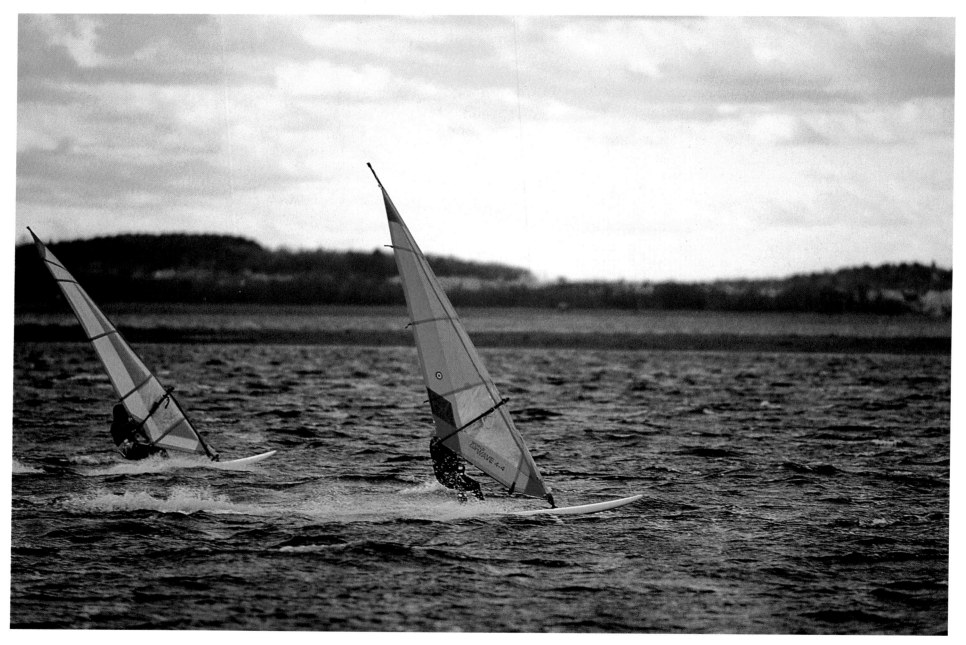

Wind Surfers

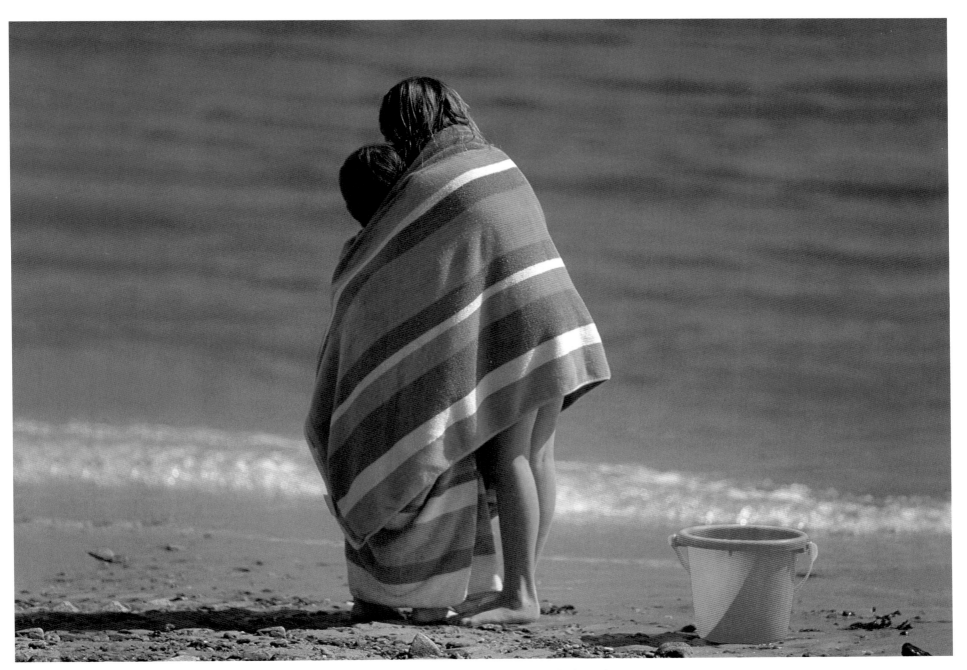

Warm Up. *Sisters Alex and Nina on Clark Beach.*

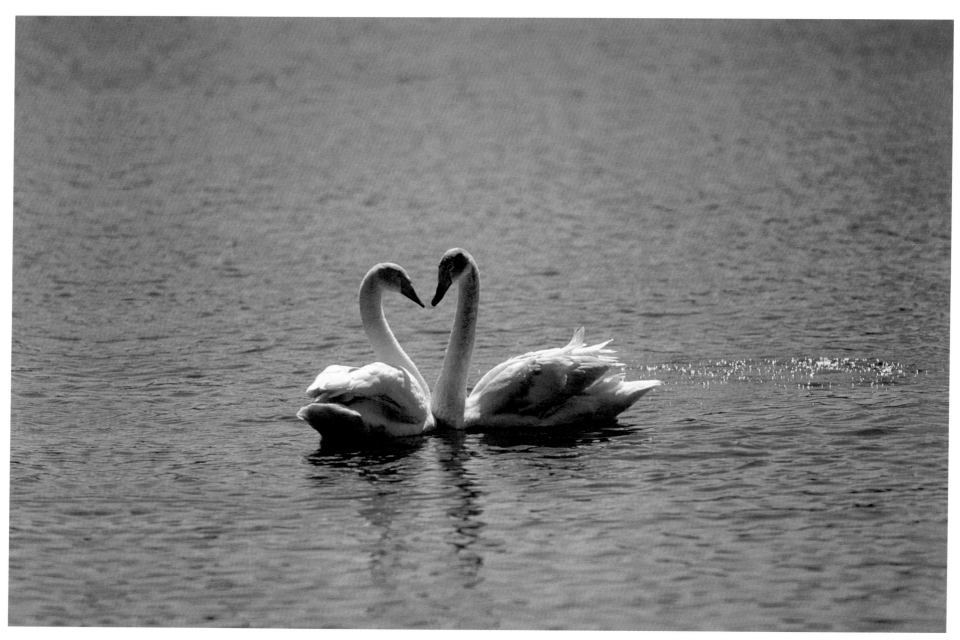

Heart of hearts, Rantoul Pond. *Swans mate for life. When one is alone, it's always sad.*